PORTRAITS OF GREATNESS

General Editor
ENZO ORLANDI

Text by
ADELAIDE MURGIA

Translator
PETER MUCCINI

Published 1968 by
The Hamlyn Publishing Group Ltd
London · New York · Sydney · Toronto
Hamlyn House, The Centre, Feltham
Middlesex
© 1966 Arnoldo Mondadori Editore
Translation © 1968 by
The Hamlyn Publishing Group Ltd
Printed in Italy by
Arnoldo Mondadori, Verona

THE LIFE
AND
TIMES OF
DELACROIX

PAUL HAMLYN
London · New York · Sydney · Toronto

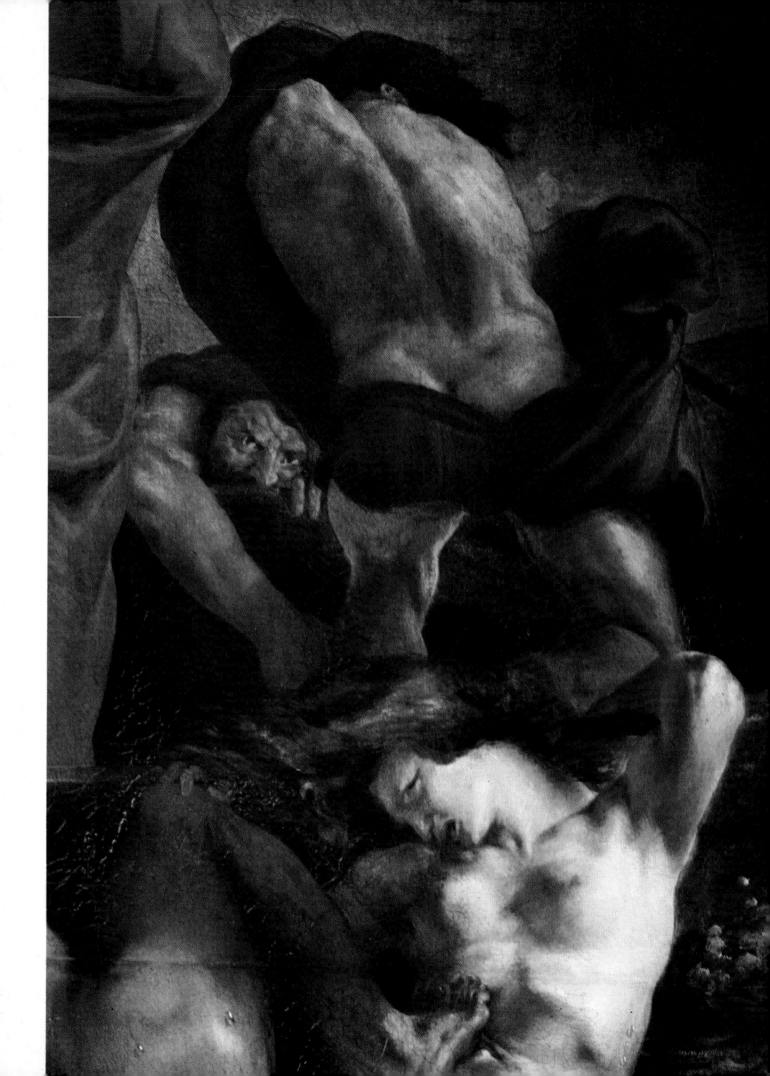

A DRAMATICALLY UNEXPECTED VISION OF DANTE

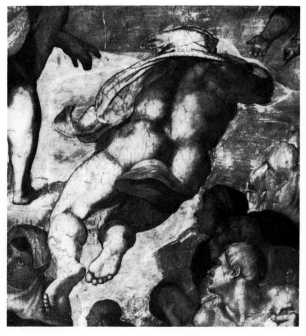

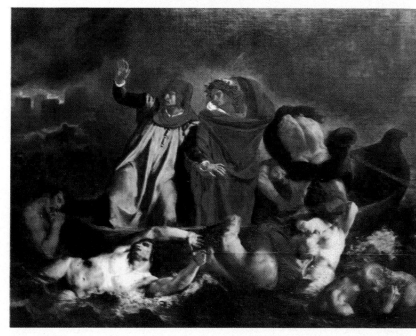

At the Paris *Salon des Beaux Arts* of 1822, the topic on everybody's lips was a new painting called "The Bark of Dante". It was by a new artist, a lean and nervous young man, one of the *enfants terribles* of the age who, robbed of the rich opportunities of the Napoleonic era, were determined to win their fame on the field of talent. Victor Hugo conveyed something of their spirit when he said: "If I were not a poet, I would have been a soldier." These men were revolutionaries who in private cultivated consumption and Byronic spleen, and in art sought to destroy tradition and all its sacred cows. Thiers of the *Constitutionnel*, a publicist and author destined for great fame, said on seeing the painting: "Eugène Delacroix has genius." To which Delécluze of the *Moniteur* replied: "You must be mad." The historians and the gossips of the day were to notice a suspiciously close resemblance between the young painter and Talleyrand, the buoyant minister to monarchies and republics. Talleyrand was indeed an assiduous family friend of the Delacroix household. Perhaps Thiers praised the painter to flatter his presumed father, without realising what a great issue he had raised.

"The Bark of Dante" (above right), the painting which made such a great impression at the 1822 Paris Salon. On April 18, 1822, in a letter to his friend Soulier, Delacroix wrote: "I have just finished a grinding task and I feel as if I have emerged from some sort of sickness. My picture is to be shown at the Salon. It absorbed me greatly and I am tempting fortune." On June 1, the painter was able to write to the superintendent of the Beaux Arts: "I thank you for the honour you have done me; I would like 2400 francs for my painting . . ." The painting was bought by the State and this did not fail to feed the gossip concerning the artist's parentage. Was he the son of the ex-prefect Charles Delacroix, or of his friend Talleyrand? Whatever the answer, Eugene was the most

alarming of the "new men", as the Romantics like Hugo, de Vigny and de Musset were called. They were the sworn enemies of the Classicists represented by David, the former recorder of Napoleonic feats, and Ingres. Delacroix's painting was inspired by the eighth Canto of Dante's Inferno. *It showed that he was susceptible to poetry and the influence of the Old Masters. The painting is in fact indebted to Michelangelo's "Last Judgement" (above left), and repeats, in the figures of the damned souls who are trying to scramble on board Charon's boat, the struggle of humanity that knows no hope. Later, Manet was to ask Delacroix for permission to copy the masterpiece. Top: a sketch for the painting, now at the Louvre. On page 4: a detail.*

DELACROIX ACCUSED FOR HIS VIOLENT "MASSACRE"

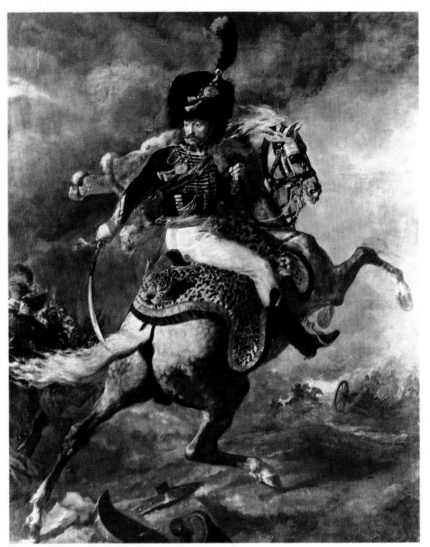

The "Massacre at Chios", inspired by the pro-Hellenism roused by Greece's struggle for independence, was a painting which, even more than the "Dante and Virgil in Hell", marked the break between the Traditionalists and the Romantics. The latter were led by Géricault, Berlioz and Hugo. Baron Gérard, the celebrated portraitist, said: "It is a picture by a man who is running along the rooftops." Baudelaire later remarked: "True, but to do this he must be sure-footed, and his eye shine with an inner light." The 1824 Salon revealed to Delacroix, through the paintings of Constable, what was to become the secret of the Impressionists: how to superimpose different shades of a colour and obtain variations of texture.

Delacroix was said to have retouched the "Massacre at Chios" actually at the Salon, on the eve of the vernissage. The figure of the Turkish officer (on the right of the painting) may be compared with the cavalry officer (above left) by Géricault. A painter who was "all genius and disorder", Géricault was a friend of Delacroix (and like him, an unconvinced pupil of the disciplined Guérin). To Delacroix he passed on his love of horses and of England. Already consumptive, Géricault died after falling from one of the fiery racehorses he loved to ride. Left: a sketch for Delacroix's painting, in the Louvre.

The massacre at Chios, which inspired Delacroix's painting for the 1824 Salon, was an episode in the savage repression of the Greek insurgents by the Turks. Newspapers of the day reported 20,000 dead and mass deportations. Born amid massacres and revolutions (Chénier, the poet whom the Terror could not silence, had been guillotined in 1794), Romanticism cultivated an erotic and Sardanapalian talent for sheer agony and terror. "My restless soul dreams of war," Hugo said; and Delacroix, as he worked on the "Massacre" spoke of the "smile of one dying, the mother's despair . . ." The Romantics plundered every field that provided them with scope for a theme of horror: Witches' Sabbaths, the Ossianic rites with which the Scottish poet MacPherson entertained the times, the cruelty of the East, and Shakespeare's darker passages. Never were there so many massacres so lovingly put down on canvas. "The Massacre at Chios of Delacroix is also the massacre of painting," said the authoritative painter Gros. Nevertheless, at the 1824 Salon, this revolutionary painting won for Delacroix the Gold Medal in the Second Class.

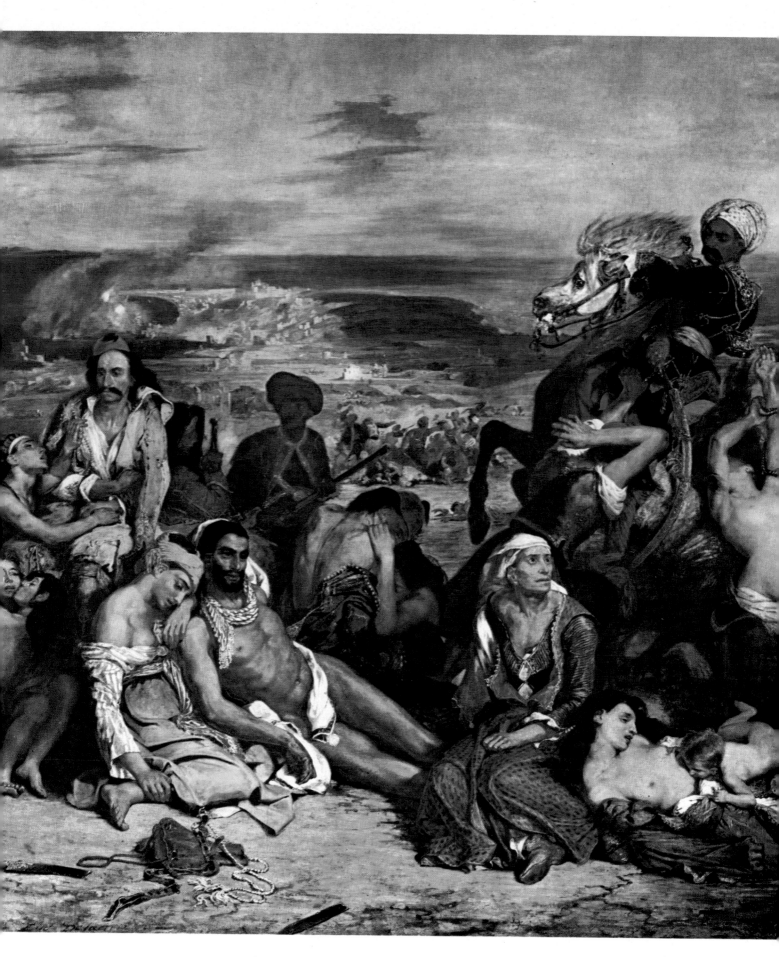

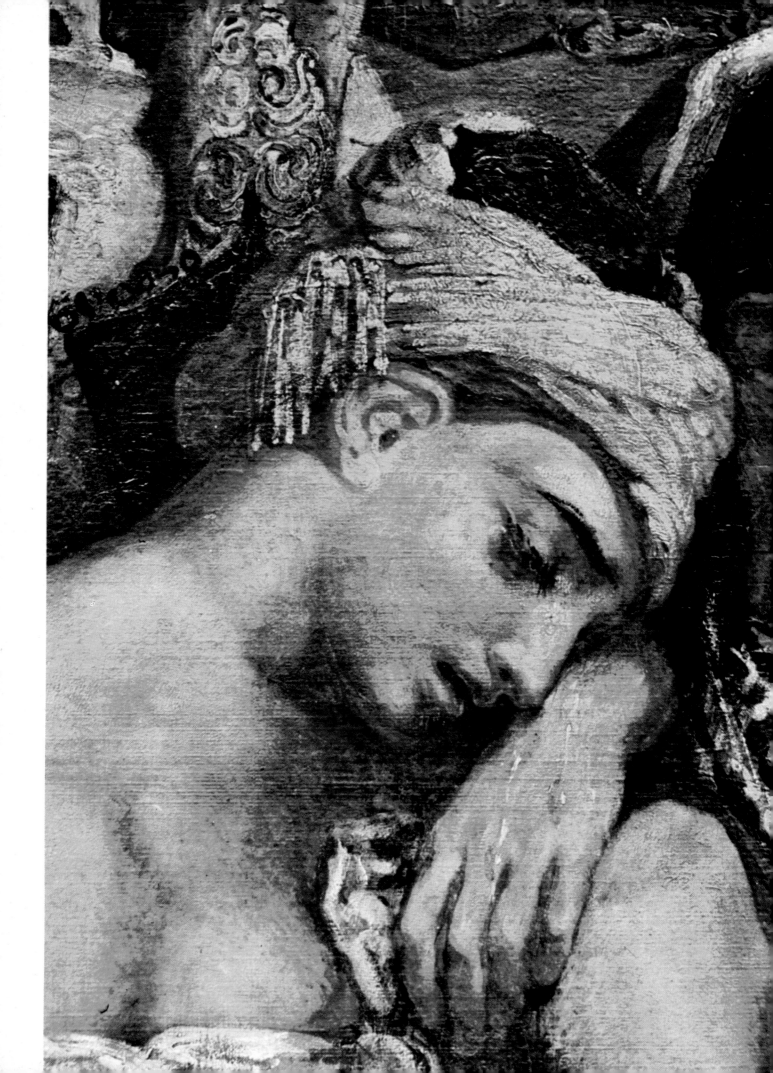

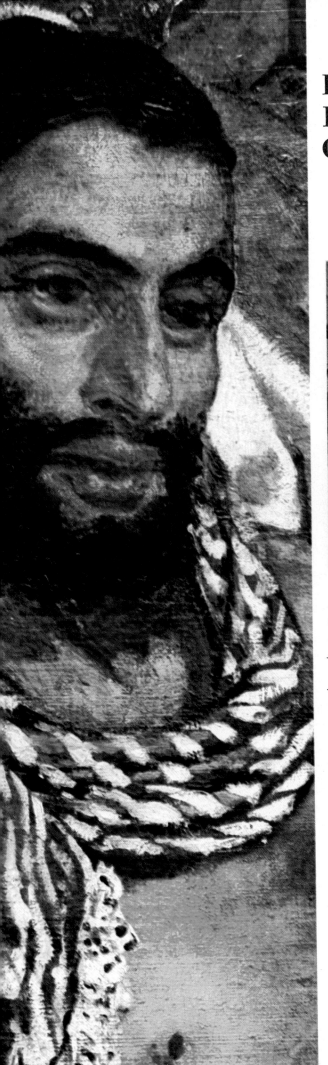

HE STROVE FURTHER THAN GROS DARED

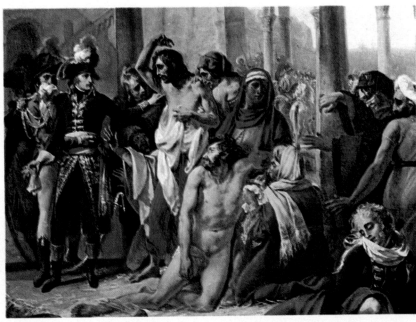

Left, a detail from the "Massacre at Chios". Delacroix's friend Pierret was said to have posed for the figure of the man. Gautier wrote of the painting: "The feverish and convulsive drawing, the rushing brush strokes and the violent colours aroused the disdain of the Classicists and the enthusiasm of the young with their strange boldness." Sosthènes de la Rochefoucauld, director of the Beaux Arts, noting the furore stirred up by the "Massacre", apparently asked the painter to "moderate" his style. This ludicrous piece of bureaucratic prudery resulted in Delacroix's indignant but predictable retort that he knew no other way to paint. To Girodet, the painter, who asked him why he had not finished the eye of a female figure, "beautiful as it is when seen from afar", Delacroix replied that if his colleague had to stand close to the painting merely to list its faults, he had better keep well clear of it. Gros did not like the painting either, though he was one member of the Establishment open to change and supported Delacroix's admission to the 1822 Salon. Delacroix considered Gros as one of his mentors. He wrote to Dumas: "The idea of painting the 'Massacre at Chios' came to me from the 'Plaguehouse of Jaffa' by Gros" (shown above).

It was Gros who had dared to paint the "real victims of the plague" and had seen in Delacroix the man who would do what he himself had not the courage to do: that is, carry through to its logical end the pictorial revolution which he had initiated. Gros committed suicide.

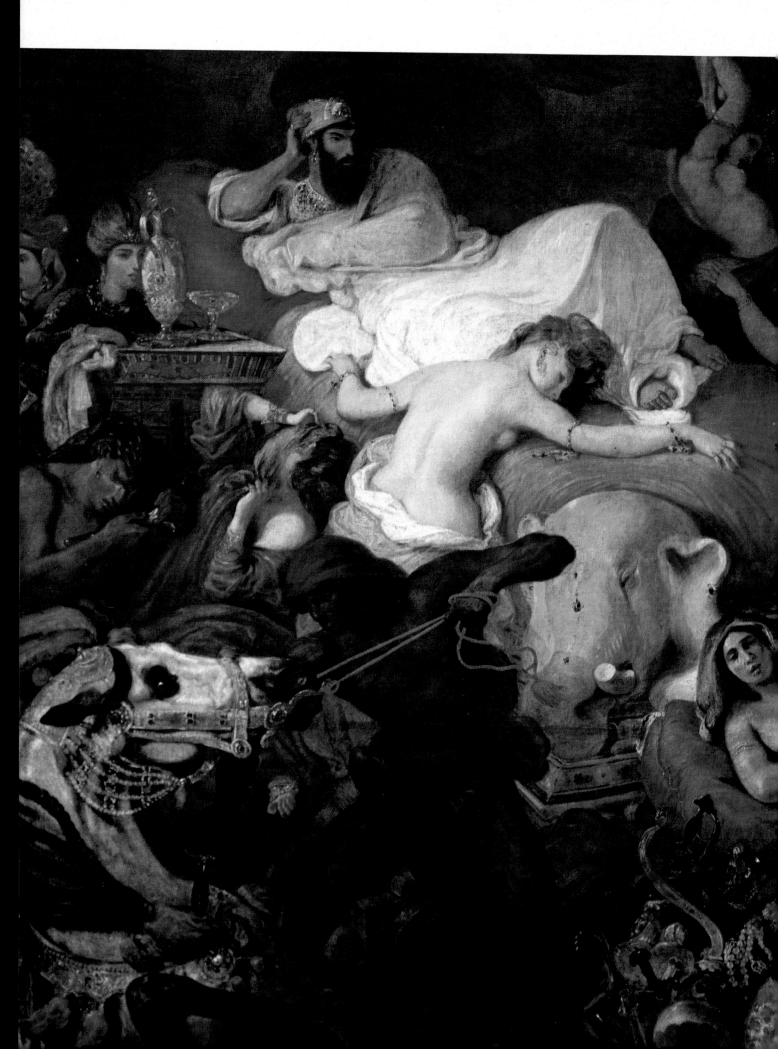

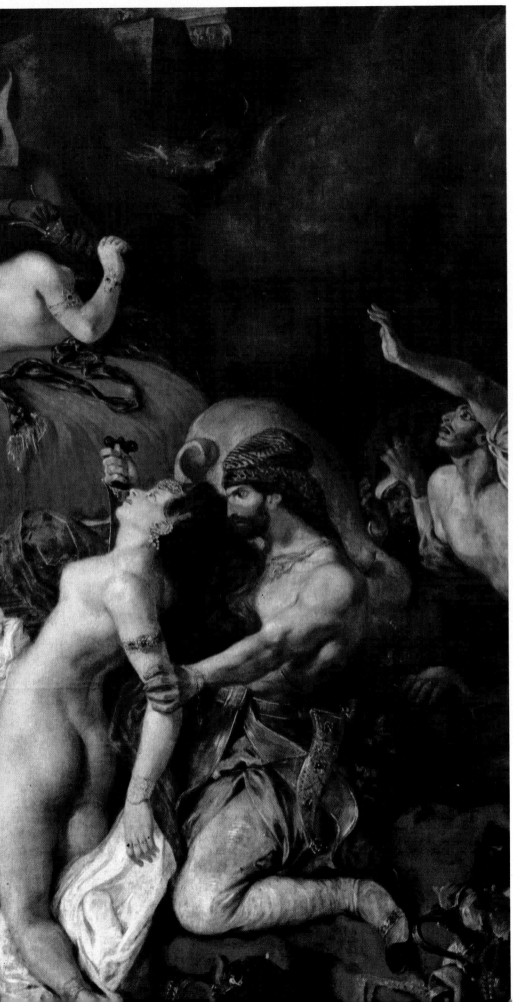

A SARDANAPALUS INSPIRED BY BYRON

"I am weary of this Salon: is my Sardanapalus a failure? I do not believe it. Some say the death of Sardanapalus is the death of Romanticism—assuming that there are Romantics! Others say that I am an ' illusion', but that it is always better to err like this. For myself, I say they are all fools. If there are certain things in the painting which I would have liked to have done better, there are also other things which I wish they had the ability to do. Vitet, in the Globe, *is inviting what he calls the Young School to break away from my perfidious independence. A careless soldier, who fires on friend and foe alike, must be dismissed from the ranks!"* **Thus wrote Delacroix to his friend Soulier. The "Death of Sardanapalus" was shown at the 1827 Salon, and it made a stark contrast with Ingres' balanced "Apotheosis of Homer". The painting, a lavish paroxysm of feelings laid bare, was not merely the painter's Romantic manifesto; it was the culmination of his juvenile style – vigorous, yet still lacking the bold technique of his later work. "It is my second massacre," he said, as if to forestall the charges of those who would accuse him of indulging in a death-orgy. The** Gazette des Beaux Arts **wrote: "Delacroix progresses only in bad taste and extravagance." The painting, now at the Louvre, was inspired by a poem of Byron's: Sardanapalus, the oriental despot, lies dying and orders that all his possessions—slaves, horses, women—be put to death before his eyes.**

11

THE ROMANTIC
TRIUMPH OF WOMAN
AS THE VICTIM

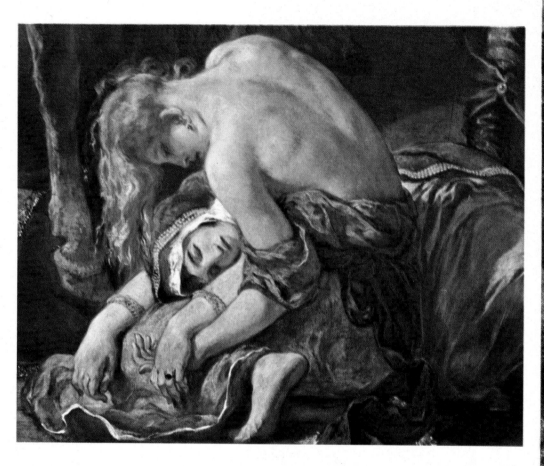

Woman as the victim, innocent and beautiful; the oppressed heroine; the unhappily married wife based on the ineluctable cliché of Desdemona; the luckless creature doomed to a premature death—this was how Woman figured in the first flush of Romanticism. (Even later in the Movement, Verdi's consumptive Violetta was cast in the same role.) Delacroix in his early period was greatly drawn to this woman-victim theme, and to express this, he chose the agony of Sardanapalus' slaves. The subject cannot be said to represent a sadistic impulse; nor is it simply a résumé of the mediaeval theme of the Triumph of Death. Nevertheless, there is a sensuality in the brush strokes which lingers over the figures of those about to die. The painter has caught the instant before death and the spectator can sense that this both moved and fascinated him.

Innocence succumbing to brutality—a theme which Delacroix in his early period embodied in these beautiful women destined for sacrifice. For the woman in the "Massacre at Chios" (centre), for the slave of Sardanapalus (right), and for the dying woman in the "Taking of Constantinople by the Crusaders" (above), there is no liberating hero, no Perseus or Roger, to come to the rescue. This was to come later. Baudelaire remarked of other Delacroix heroines, such as Medea and Cleopatra: "Delacroix's women have the fascination of crime and the halo of martyrdom."

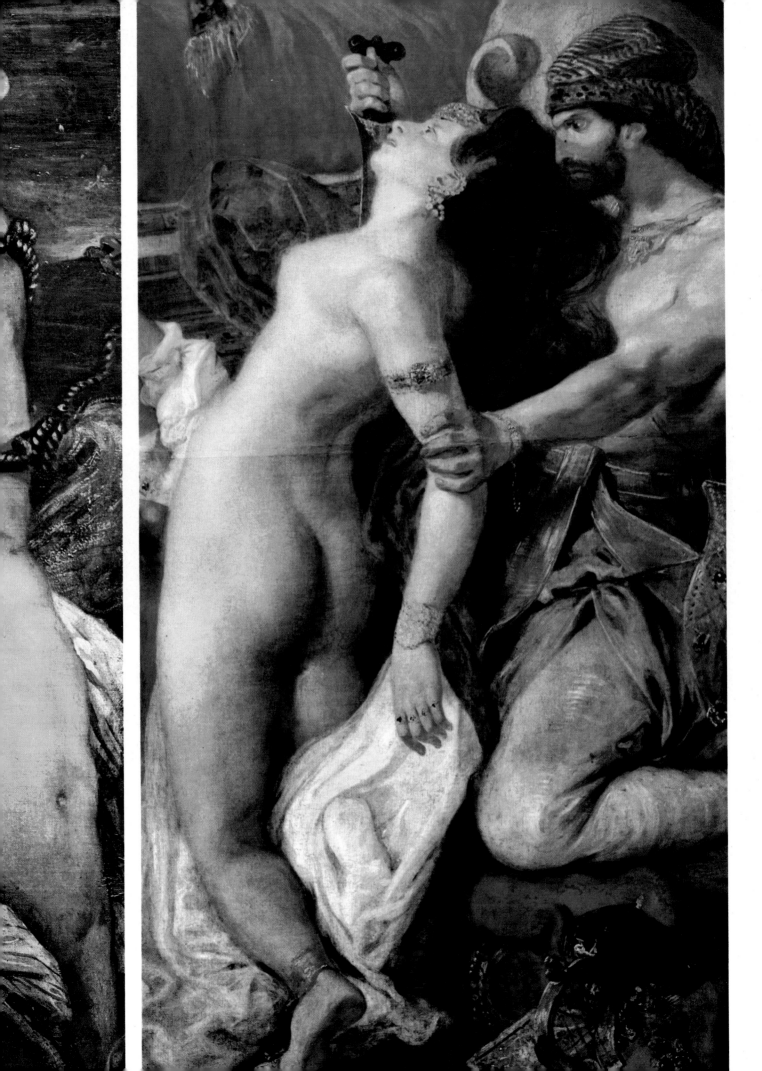

TROUBLED SHIPS
AND THE ETERNAL
THEME OF THE SEA

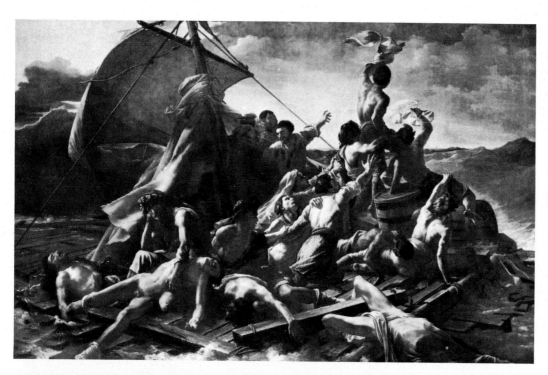

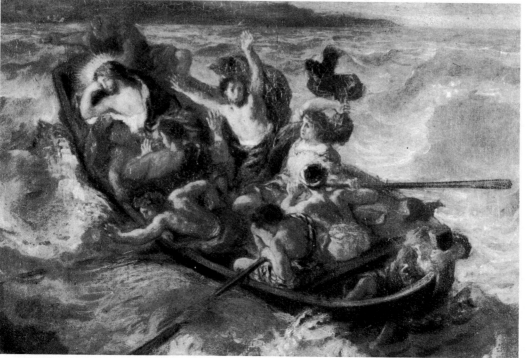

"The Raft of the Medusa" (above left), by Géricault, was shown at the 1819 Salon under the less dramatic title of "Shipwreck Scene". The painting was inspired by the wreck in 1816 of the French frigate Medusa. *The few survivors were found on a raft at the point of death. This tragic incident was to become a great source of inspiration to the Romantic Movement. Delacroix, a friend of Géricault, was said to have posed for one of the central figures. Left: "Christ on Lake Galilee" (Paris, private collection); Above right: "The Shipwreck of Don Juan" (Paris, Louvre Museum); "After the Shipwreck" (Leningrad, Hermitage Museum): three paintings by Delacroix which owe a debt to the Medusa incident.*

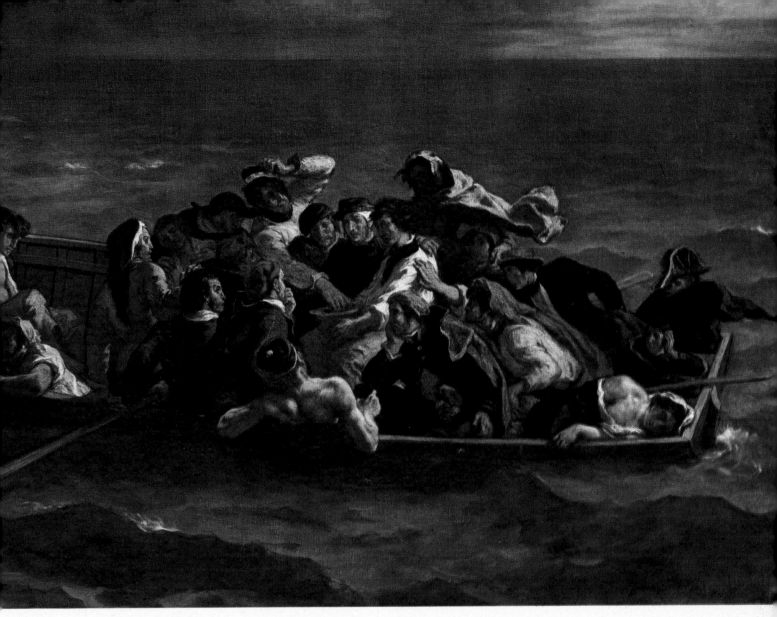

"Driven to new shores, dragged into the eternal night whence there is no return: can we, on the ocean of time, ever cast anchor?" Lamartine was 27 when he wrote these lines by the Lac du Bourget, with Julie, an ailing lady, in his thoughts. "Man has no harbour and time has no shore. Time passes, and we pass with it." It was 1817 when Lamartine's plangent notes mourned the dashing of his hopes. Mallarmé had not yet appeared on the scene; and his "Brise Marine" in which sea-birds "intoxicated at being amid the unknown seas and skies" circle a ship in desperate search of escape and freedom, was not known to Delacroix. Yet Delacroix, without benefit of familiarity with the new

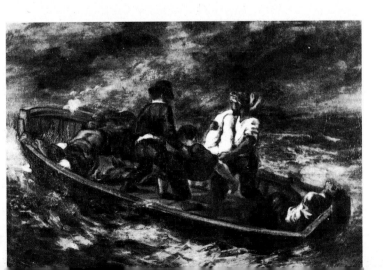

thinking of Mallarmé's day, himself felt a certain "sadness of the flesh". When he sought escape in the timeless theme of the sea, he did so in a more mordant vein than Lamartine and more metaphysically than Mallarmé. In 1822, he had descended into Hell with Dante and Virgil. There he found a humanity powerless save to scream out its own despair. At Valmont, in 1840, the stormy sea inspired the theme of the painting which he showed at the Salon in the following year. (He later wrote to Mme. de Forget: "You know my passion for the sea".) Tragedy is at the helm in "The Shipwreck of Don Juan" (1840), another tribute to Byron. The survivors draw lots to decide which of them is to be eaten, so that the rest may stand a chance of survival. In "After the Shipwreck" (1847), man reacts: battered, but undefeated in his fight against the elements, he struggles to his feet once more, he re-organizes himself, he refuses to give in. In "Christ on Lake Galilee" (painted in 1854, nine years before the artist died), Christ remains unmoved and asleep during the tempest. This was evidently meant to indicate that hope existed of overcoming life's adversities through transcendental spiritual strength. But in 1862 the ship returns in a more enigmatic guise. It runs before a fearful wave and the people on board are dim figures lost against the background. Is this the unknown end to the voyage? The artist does not say.

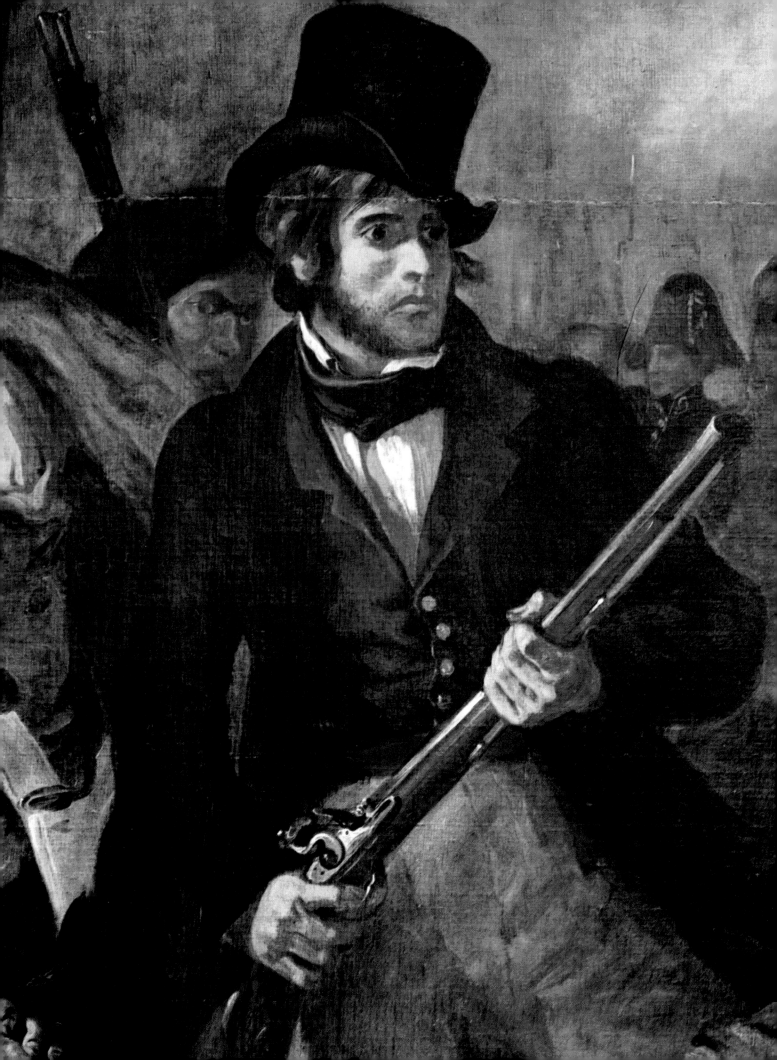

A REVOLUTIONARY IN PAINTING; A CONSERVATIVE IN POLITICS

That such a conservative as Delacroix should have painted "Liberty Leading the People" (below), is not so surprising in that many of the 1830 insurgents were Orleanists and Bonapartists— all men loyal to the king. The painting (at the Louvre Museum) was bought for 3,000 francs by the government of Louis Philippe, the Citizen-King brought to power by the events of 1830. With the rise of Thiers, a new era of important commissions from the state began for Delacroix. Below: a sketch for the "Liberty", and a detail from "Greece Dying at Missolonghi" (Bordeaux, Musée des Beaux Arts). Left: A probable self-portrait of the painter in the "Liberty".

"This liberty won at so high a price is not true liberty. True liberty consists of being able to come and go in peace, of being able to think, of being able to dine at the proper times, and of many other advantages for which political agitation has no respect. Please forgive these reactionary thoughts of mine . . ." Thus wrote Delacroix to George Sand immediately after the 1848 Revolution. Although he was an innovator in art he was a passionate conservative in his political thinking. He was born into the upper middle class, but following the economic collapse of his family he was obliged to take up caricature to earn a living and the discomforts of the bohemian life never amused him as they did others. However, from the very start of his career, he enjoyed the patronage of the Establishment, in the persons of the powerful Thiers and Talleyrand. Thus it was hardly surprising that Delacroix, for all his artist's individualism, should prefer social order and legality, and should contemplate with apprehension any upheaval that might destroy the status quo. (In 1848 he cancelled a trip to Italy, which was on the point of plunging into an age of revolutions. He wrote: "I would like to be one of the *ancien régime* when it was forbidden to take part in politics. In Italy, until six months ago, they thought only of amusement and love. Fools! Do they really think time cannot be spent in a better way?".) His brother was a General with Napoleon I. His father was a prefect and a minister. So it was hardly strange that he should respect only the name of Napoleon. After the Revolutions of 1830 and 1848 he drew a sigh of relief only when power returned to a legitimately crowned head. In 1856 he sat up till dawn at the Hôtel de Ville like a good civil servant (he was a member of the Buildings Commission of Paris), waiting for the Empress Eugéne to be safely delivered of an heir to the throne. Even in music his taste was conservative. "I have heard this Verdi who is creating such a furore these days," he wrote in 1847. "He has no ideas, merely cast-offs of Rossini, nothing but discords . . ." In truth, it may be that Delacroix was disturbed by Verdi the patriot who, in works such as "The Lombards at the First Crusade" could be recognized as a potential agitator against the established order.

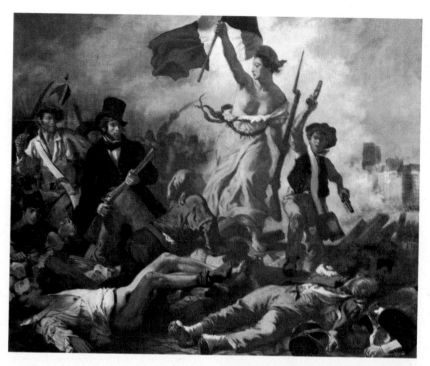

TWO VENETIAN TRAGEDIES: FALIERO AND THE FOSCARI

"The Execution of Marin Faliero" (below right). Marin Faliero, the Doge of Venice who was beheaded for an act of treason, had already been the subject of a play by Casimire Delavigne. The play, first performed in Paris in 1825, condemned the tyranny of the Venetian Republic, of which Faliero had set himself up as

judge. Perhaps Delacroix shared this feeling. Perhaps also he devoted his other Venetian painting to the two Foscari because he wanted to show that revolution does not pay. The Faliero painting, done in 1827, was one of the artist's own favourites, and won great acclaim in London. It was an architectural similarity

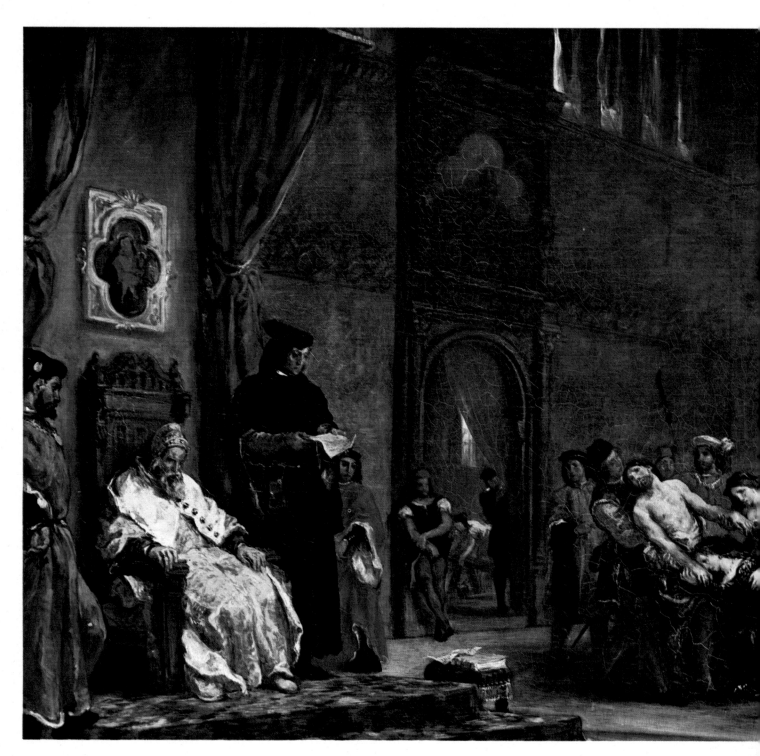

with Bonington's "Stairway of the Giants" (right). The Faliero story inspired Byron (1821) and Donizetti (1835). Below: "The Two Foscari". The Doge Francesco does not speak against the sentence passed upon his son; while he himself is to be deposed. This theme also attracted Byron, and in 1844 Verdi used it in an opera.

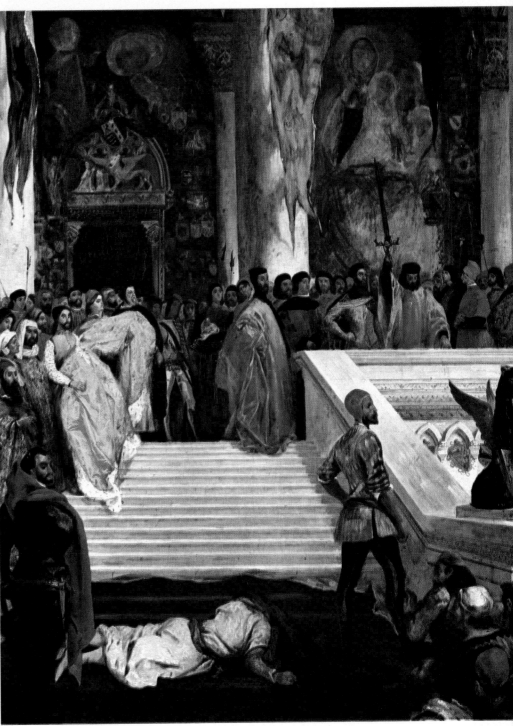

"Homage to Delacroix": Fantin Latour's painting was shown at the 1864 Salon, a year after Delacroix's death. Portrayed are a group of neo-Impressionists who, like Delacroix, were all accused at one time or another of not being able to draw. From left to right (background): Cordier, Legros, Whistler, Manet, Bracquemond, and an unidentified sitter. Foreground: Duranny, Fantin Latour, Champfleury and Baudelaire. In the middle is a portrait of Delacroix. A greater homage was to be paid at the 1872 Salon with Renoir's "Les Femmes d'Alger". Right (left to right): Byron (1788–1824), Michelet (1798–1874), and the writer Eugène Sue.

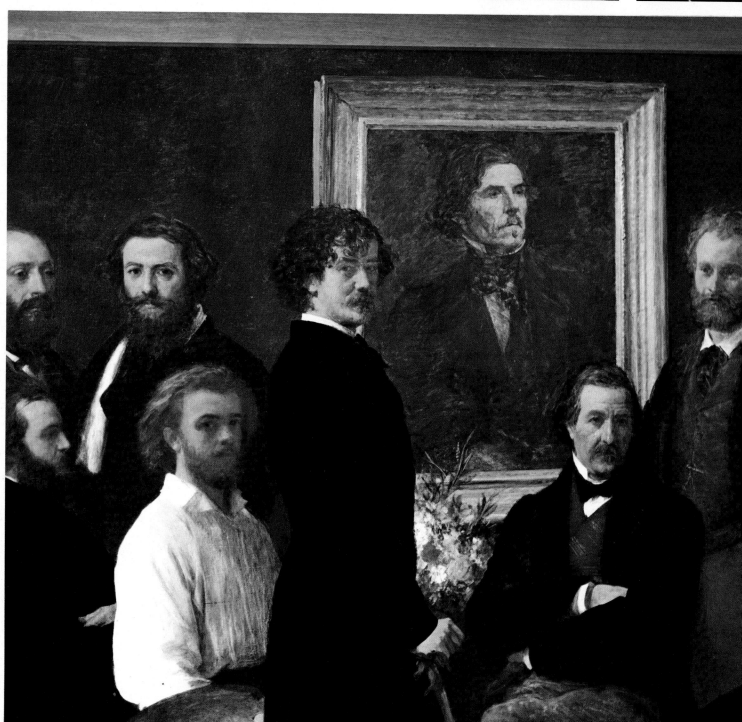

Gautier Berlioz Hugo de Nerval de Musset Riesener Bonington

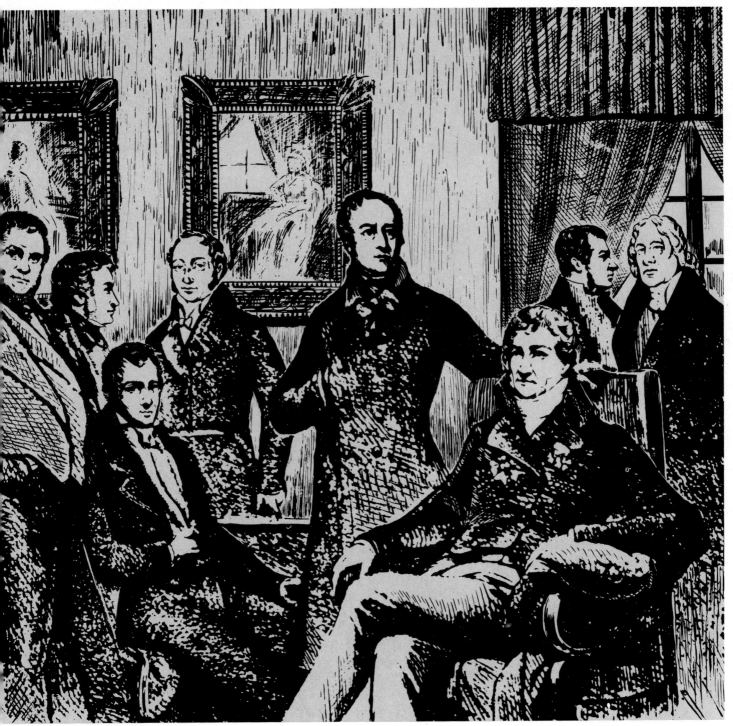

DANDYISM: THE STYLE THAT BECAME A WAY OF LIFE AND A PHILOSOPHY

Below: Some caricatures in the English style by Delacroix. The painter was initiated into the cult of Dandyism during his stay in England in 1825. He continued to be a devotee when he returned to Paris. English Dandyism—that is, authentic Dandyism—tended to conceal a vacuum of ideas beneath an impeccable external veneer.

The French version had a spiritual motivation and reflected a genuine inner discipline. When Delacroix conversed with Baudelaire (who was one of the outstanding Dandies of the time), he could say "My dear sir" in twenty different ways which, to a practised ear, would convey a complete spectrum of feelings.

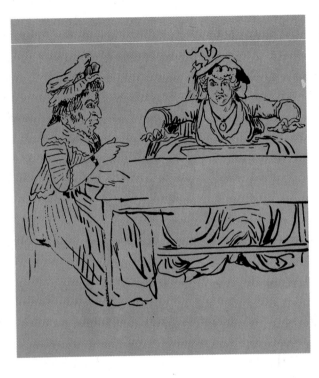

"I had fallen into that condition which my doctor called a lack of tone—not, you must understand, social tone, because a Dandy of my vigour is always well-provided with that," wrote Delacroix to George Sand in September 1841. Nineteenth-century Dandyism of the pure style was not a fashion, and was much more than a "wardrobe of philosophy". It was a spiritual attitude, a way of life and a philosophy. Baudelaire, for example, looked upon it as an offshoot of Stoicism. It was the cult of the outer Ego as the highest expression of an incorruptible individualism, and its most striking external manifestation was the display of a total disregard for the norms of social manners. In his dress and in every aspect of his behaviour the Dandy had no accidental attributes. Delacroix affected the style as he affected bespoke shoes, a taste to which he converted all his close friends; special neckcloths to which he entrusted his delicate neck; and such a soft way of pronouncing his "r's" that it never failed to astonish a young female cousin of his, who could not believe that a man of his mature years could have such an affectation of speech.

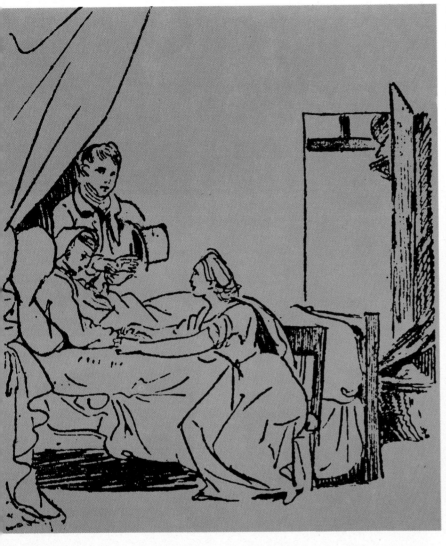

Caricature, which reached its height in England during the nineteenth century with Seymour and Hogarth, also had its masters in France. These were represented by artists like Daumier, Monnier, Gavarni, Pigal, and Delacroix's friend Charlet. In his youth Delacroix drew several caricatures for the Miroir to pay his debts.

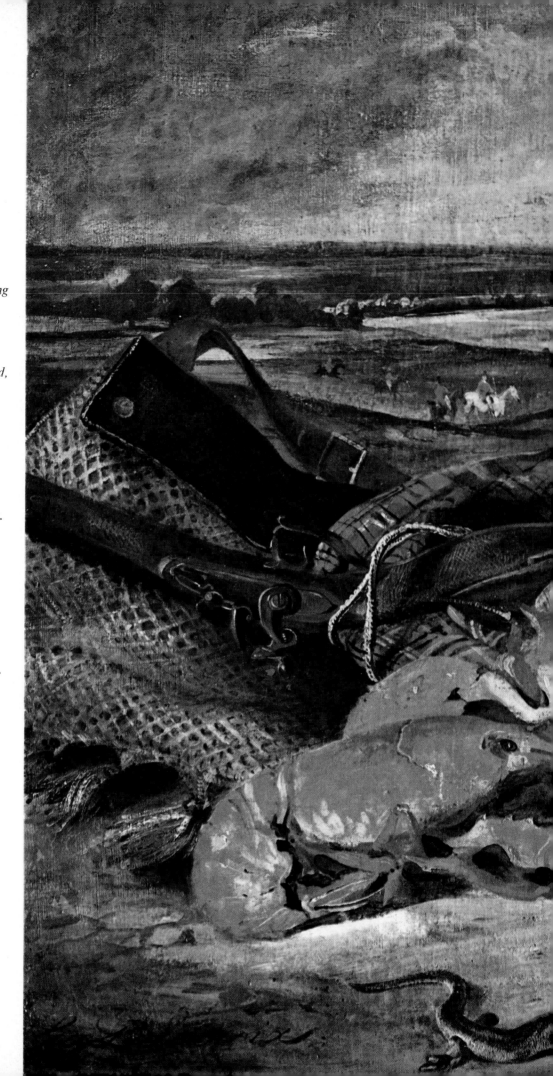

NATURE OPENED HER BOOK FOR HIM

"How many things and, more, how many men, are changed by remaining silent about all that is gone! A month ago they showed me that picture of animals I painted at Beffes, twenty years ago. The poor Marquis de Coëtlosquet is now dead, and the painting was being sold. Everything ends up at the auctioneer's; he seems to be a sort of universal undertaker," wrote Delacroix to his friend Soulier on March 23, 1850. The painting was "Still Life with Lobsters" (1827, Louvre). Delacroix was greatly intrigued by every aspect of Nature. Often he felt it as a ruthless and inexplicable force, and this is well illustrated in his powerful images of horses frightened by lightning. Paintings such as his strange "Oak-tree in the Forest of Sénart" convey the same sense of awe. But Delacroix was capable also of more conventional and restrained landscapes; and he never tired of painting the huge bunches of flowers from Nohant which Joséphine de Forget often sent him. His technique, with its bold but precise use of colour, heralded the coming of the Impressionists. One of the basic concepts of his aestheticism was "not to sacrifice truth for a Nature that was too fussy in details. The essence of art is to re-create Nature, not to copy it". Nature for Delacroix, as Baudelaire remarked, was "a vast dictionary, the pages of which he consulted with a sure and knowing eye. This is the kind of painting which springs, above all, from memory, and which speaks, above all, to memory".

26

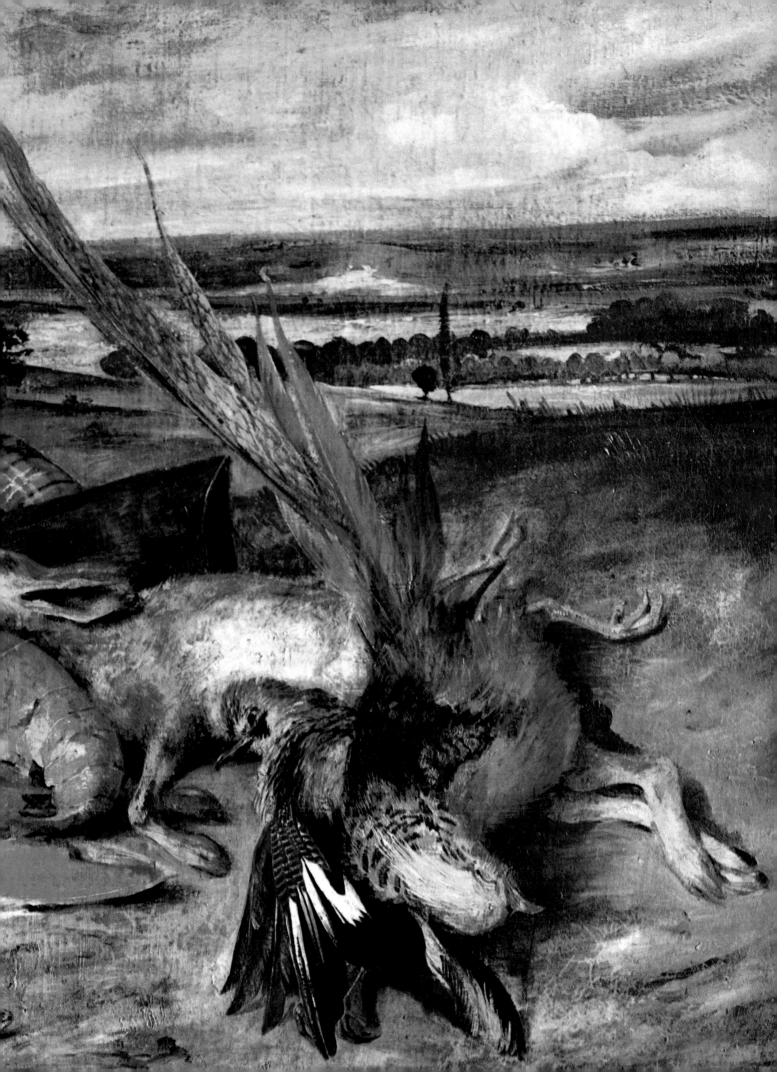

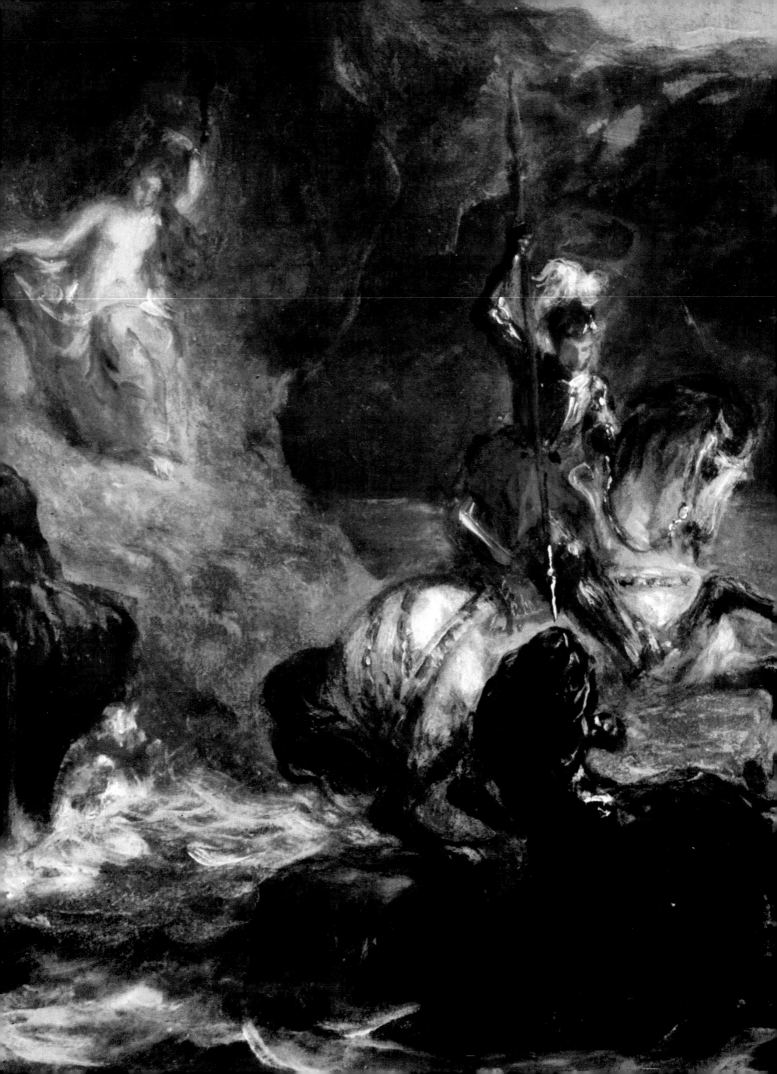

*Left: "Roger rescues Angelica"
(1847); even in this stylized
fantasy with its typically
romantic hero and nostalgic
medievalism Delacroix still
achieves a feeling of reality. This
painting is now in the Louvre,
along with much of his other work.
Below: "Tasso in the Madhouse"*

THE TORMENT AND THE ECSTASY OF A MAN ENSLAVED TO ART

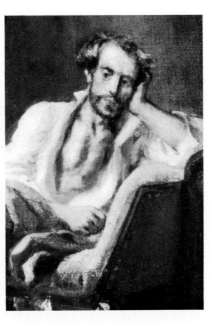

*(Winterthur, Oskar Reinhardt
Collection). Several versions of
this painting exist (1824, 1825,
1827). The last of these, given
by Delacroix to Dumas, was later to
prove an asset to the thriftless
novelist. Above right: "Michelangelo
in his Studio" (Montpelier, Musée
Fabre). "I see him," wrote Delacroix,
"in the dead of night, terrified by his
own creations ... Tormented by
his failure to consummate his
sublime ideas in painting, his restless
spirit seeks refuge in poetry. In his
poetry Michelangelo managed to
express, I believe, not only his
nostalgia for the golden days of the
past, but also the profound
melancholy and anguish—the dread,
indeed—which the prospect of the
days that lay ahead induced in him".
This ineluctable sadness, which
welled up from the contemplation
of the riddle of man's destiny, was
also shared by Delacroix.*

Delacroix never visited Italy. In 1854 he wrote: "I had the idea of going to Italy, but my slothful nature was terrified by the prospect of such a long voyage..." However, he learned about Italy through its great painters and poets. The fine ladies and the gallant knights of Ariosto inspired several of his paintings ("Marfisa", "Roger Rescues Angelica"). His "Angelica helps the wounded Medor" sees the introduction of a compassion for "irremediable pain" as part of his theme. Delacroix was greatly struck by Tasso's unhappy fate. The poet, shut away in a madhouse, became for him the symbol of the frailty of genius, prone to madness and the scorn of men. Delacroix was also intrigued by the reclusive Michelangelo. He copied many of his verses into his *Journal* and wrote a critical essay on his work (1837). In "Michelangelo in his Studio" (1850), there is the feeling that the picture tells much of Delacroix himself. Just as Michelangelo, with a flickering candle fixed to his head to light up his statues and his loneliness, struggled to the very last day of his life, so Delacroix increasingly discovered that only his work gave him the impetus to survive. Like the Florentine, he learned that "Art is a lady who seeks to possess her man completely".

LIKE HUGO, A DEVOTEE OF SHAKESPEARE

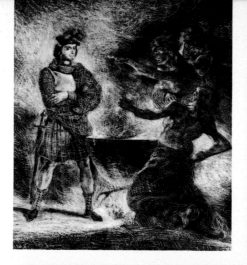

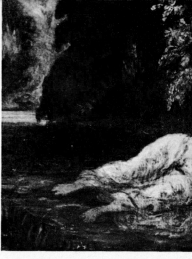

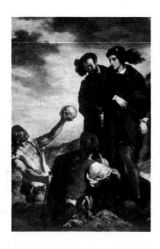

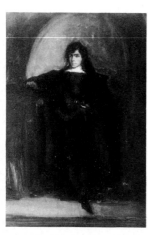

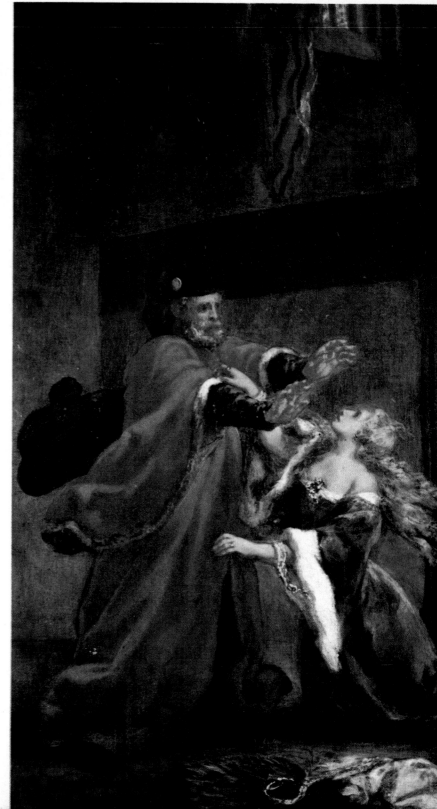

As a youth, Delacroix loved Shakespeare. In 1821 he painted himself in the costume of a listless but disturbing Hamlet. And in 1816 he had embarked in the name of the English poet upon a series of adolescent, clumsy sonnets, written in laborious English under the pseydonym "Yorick" and enclosed in a letter addressed to Elizabeth Salter, a maid in the service of his sister, Mme de Verninac. For Delécluze, the spokesman for the Philistines, this letter proved to be a heaven-sent weapon for attacking Delacroix as one of the chief members of the Shakespearean faction. Many years later, Delacroix, either through personal conviction, or in order to curry favour with the electors of the *Institut*, abandoned the Bard. But in the intervening years Kean and Kemble, actors he had admired at the Drury Lane Theatre in London, found their way into fantasy paintings devoted to Shakespeare. There were many of these. In his painting of Macbeth and the witches, done in 1828, the theme was of the occult powers which tempt humanity. His Hamlet of 1839 meditating on Yorick's skull is yet another aspect of Delacroix's *alter ego* speculating on the vulnerability of genius. His Desdemona of 1852 is one of his typical ill-fated women. A series of Shakespearean lithographs, done between 1834 and 1843, represented a distinct revival of the Romantic temper of his earlier years, and the ghosts and souls in torment that they portray may be seen as a heartfelt reaction from the Classical manner of the painter's frescoes of this period.

In 1827, five years after they had been greeted with jeers and pelted on stage, Shakespeare's plays were revived in France. On this occasion, Delacroix was able to write: "The English have indeed worked miracles by filling the Odéon to capacity. Every street in the quarter is shaking under the weight of carriages rolling up to the theatre." From their boxes in the theatre, Hugo, Sainte-Beuve, de Nerval, de Vigny, Dumas and Delacroix gave their most fanatical support to the performances. Berlioz indeed found himself a wife in the person of the English leading lady, Harriet Smithson. Delacroix used her as a model in one of his paintings of the death of Ophelia. Above left: two etchings, "Macbeth and the Witches" and "The Death of Ophelia". Far left: "Hamlet and Horatio in the Graveyard"; "Self-Portrait in the Costume of Hamlet". Below left: "Desdemona with her Father". Below: "The Death of Polonius". These last four works are now in the Louvre.

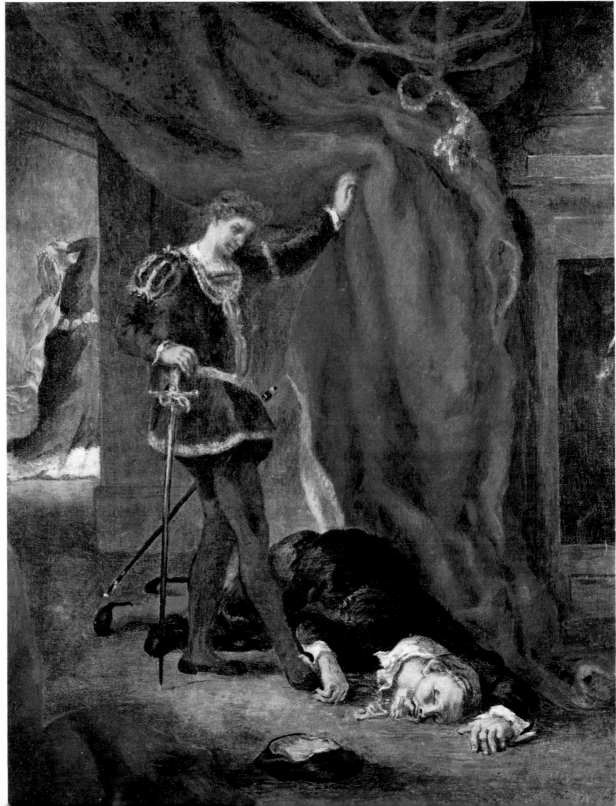

THE MIDDLE AGES: A GOLD MINE FOR THE ROMANTICS

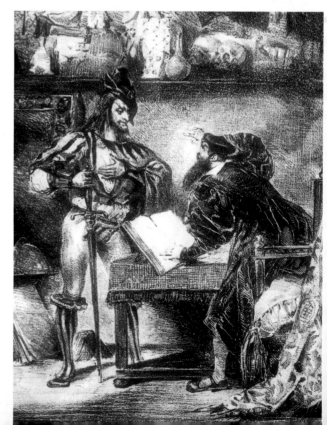

The Middle Ages, one of the rich sources tapped by the Romantics, also attracted Delacroix. At Valmont, with his cousin Bataille, and at Rouen with Riesener, his uncle, whose son Léon was also a painter, Delacroix studied stained glass and Gothic architecture. The novels of Walter Scott, whose sombre medieval themes were very much in vogue, provided him with many principals for his pictures. "The Murder of the Bishop of Liège" (on the opposite page) is taken from Scott's Quentin Durward. William de la Marck orders the bishop's throat to be cut before a crowd of revellers at a feast. Gautier said of this painting: "Who would have thought it possible that sound and tumult could be put down on canvas? The movement is endless and the small painting shouts, clamours and blasphemes . . ." The white tablecloth, a pictorial stroke from a palette that was no stranger to the techniques of Rembrandt, was described by Delacroix as "My Waterloo or my Austerlitz". He stipulated that the painting should be seen in artificial light. It was exhibited at the 1831 Salon and later bought for 3000 francs by the Duc d'Orléans. Above: a sketch for Goethe's Faust, "Gretchen and Mephistopheles". Right: two lithographs, "Mephistopheles tempts Gretchen in Church" and "Mephistopheles offers his services to Faust".

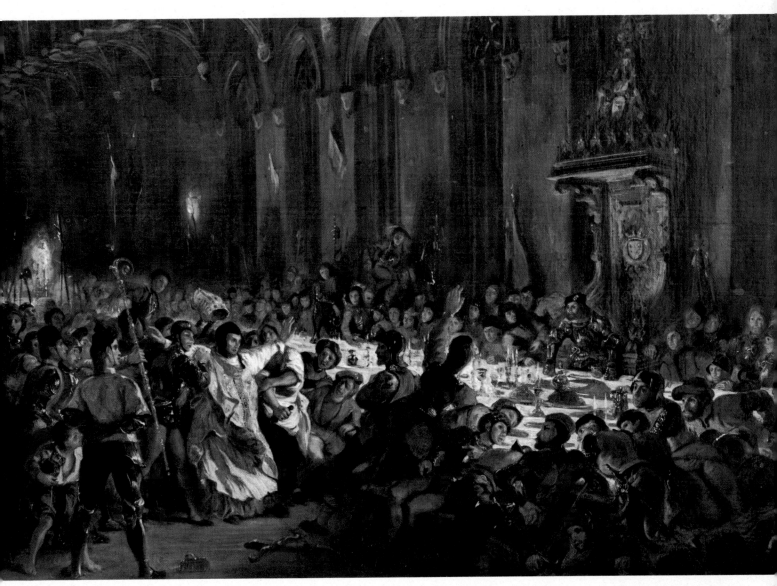

The Romantics were lavish in their homage to Goethe. This was particularly true of the composers of the period: Schubert's Gretchen, Berlioz's damned Faust and compositions on the same theme by Liszt and Wagner were all greatly admired. Perhaps the superiority over all the other arts which the Germans attributed to music played no small part in this. Delacroix, too, felt that as a painter he had to pay his own tribute to Faust, that outstanding symbol of all man's unsatisfied wants, and dedicated to him a series of lithographs, begun in 1828. In this, his thirtieth year, the artist was already given to meditation on the vanity of all things human. He had dutifully fulfilled all his youthful obligations to worldliness, and he now felt that the tedium of life was beginning to catch up with him. He wrote to Pierret, who had introduced him to Peter Cornelius's drawings for Goethe's "Faust": "Things no longer hold the fascination that they once held: where is the rosy glow of other days? I'll be damned, but everything is stupid: myself, you, the other fellow, the whole world . . ." Delacroix was far from starved of German culture which, with translations of Kant and the music of Beethoven, had begun to penetrate France at the beginning of the century. He was familiar, also, with Mme de Staël whose celebrated "De l'Allemagne" had been suppressed under the Napoleonic regime. Now that the book was freely available again, it was widely read and widely acclaimed, and its influence on Delacroix was by no means negligible. He had also copied the thoughts of Goethe into his *Journal*: "I would like to give up words and, like Nature, speak only in images." Goethe himself was greatly impressed by Delacroix's "Faust" lithographs. The poet said of them: "The artist has assimilated from this dark work all the sombre quality it contained in its original conception." But there was a price to be paid for Delacroix's fidelity: it was obvious that this comprehensive assimilation of Germanicism was responsible for the scant success which the Faust lithographs met with in France. However, the painter turned down an offer to paint Goethe's portrait as a frontispiece for a volume of the lithographs. He wrote in 1827: "I regret it greatly but it would disturb all my present arrangements. I have to finish my painting ("Sardanapalus"). and I have to go on two journeys." So he suggested instead of the portrait a medallion should be used as a frontispiece.

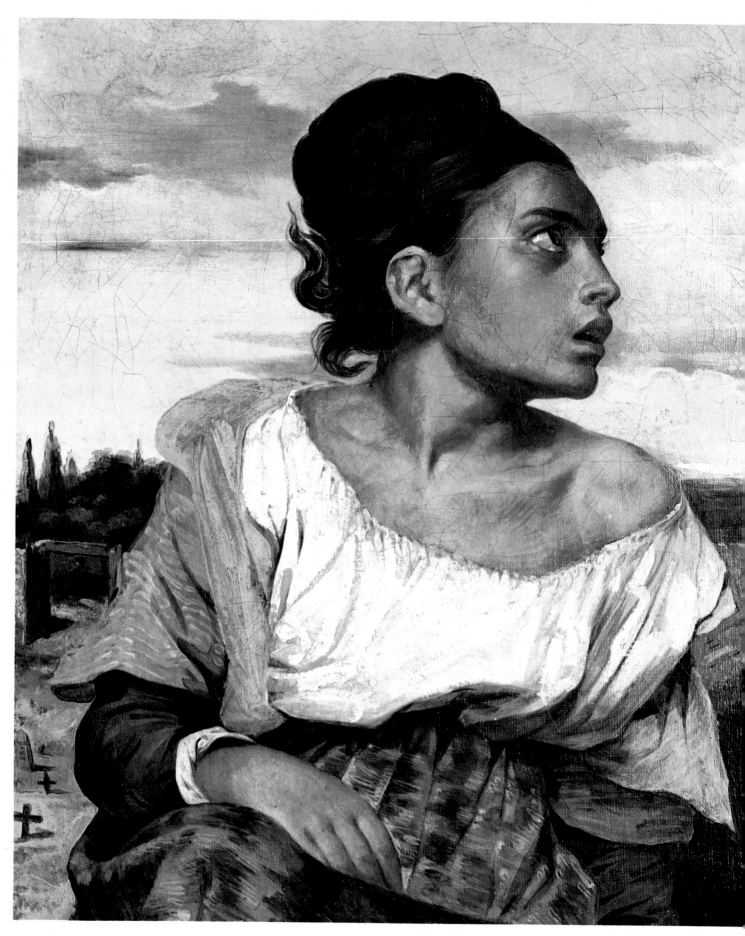

MANY WOMEN BUT ONLY ONE LOVE

"There is nothing that fascinates me as much as painting. My life is completely dedicated to it. I am like Newton, who, if I am not mistaken, died a virgin, intent on his researches into the theory of gravity." These lines faithfully reflect Delacroix's true love: his art. Women, for him, meant love affairs. Although he attached importance to these affairs, his essential egocentricity and fickleness may be seen in what he had to say about women and marriage. "Dear Raymond, I envy you and cannot wait for the day when you marry..." "Marriage? It has taken some of my best friends away from me..." "A wife who comes up to one's standards is the best thing of all" (he was only 23 when he said this). "... Ah, to have land and property, to eat rabbit fed on one's own grass—that would be the situation to get married in..." "... Women, my dear Baudelaire? Byron is right: they are empty-headed creatures, fit only for mirrors and bonbons..." "... Cohabitation with a woman always exerts a profound fascination ..." This ambivalent attitude—this mixture of idealism and scepticism—did not prevent him from having an eventful love-life. There was Mlle de Rubempré, who dressed like "a fortune teller" and specialized in writers. Mme Dalton, who had been mistress of both Vernet and Bonington, was Delacroix's mistress for seven years from 1825. In 1834 the artist became inseparable from his cousin Josephine de Forget, and the relationship soon slipped into the routine of conjugal life. Josephine became a widow in 1836, but he would not marry her; she did not understand his love for the country. She sweetly irritated him as he lay on his deathbed with the rustling of her skirts as she moved about the room, but they never quarrelled. To George Sand he wrote affectionate and frivolously philosophical letters. For Jenny le Guillou, the untutored Breton working girl, he turned Pygmalion and took her on conducted tours of the Assyro-Babylonian Room of the Louvre. Jenny was with him when he died. She won his gratitude by the quiet way in which, during his last days, she built a wall of isolation round him, that protected him from the silly distractions from the world and enabled him to live undisturbed with his one true love – his painting.

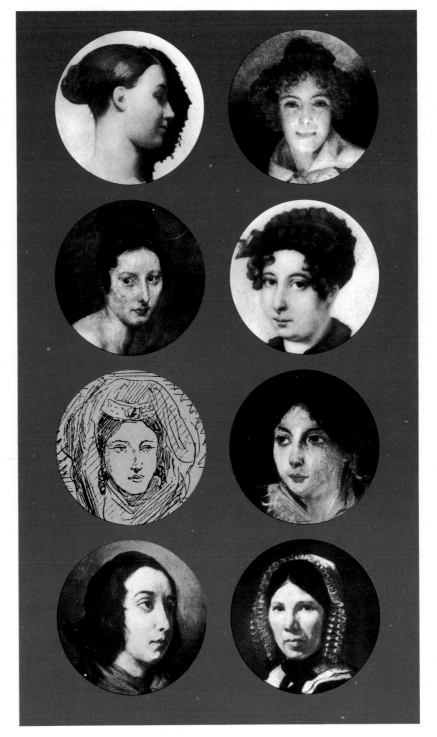

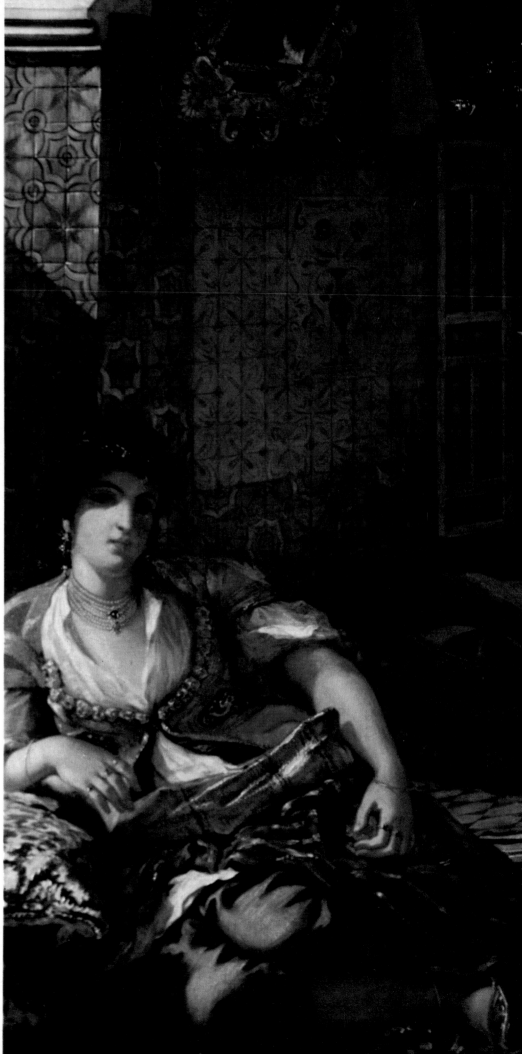

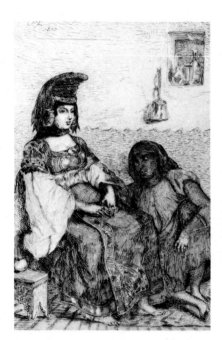

"As I approach this painting I can smell the fragrance of incense slowly burning." Renoir said of Delacroix's masterpiece "Algerian Women" (Louvre). The purchase of the painting by King Louis-Philippe prompted Hugo to remark: "All Europe is looking eastward. Why not the King, then?" The portrayal of these gently indolent Algerian women, absorbed in a kind of voluptuous melancholy, eclipsed such previous works in this genre as Scheffer's "Turkish Women" (1827) and Ingres's "La Grande Odalisque" (1814), and represents par excellence Delacroix's idealistic vision of Woman as an enslaved and unfortunate creature. He expressed his alarm at "the Parisiennes who have been given so much freedom that they should be kept in check". Above: "An Algerian Jewess".

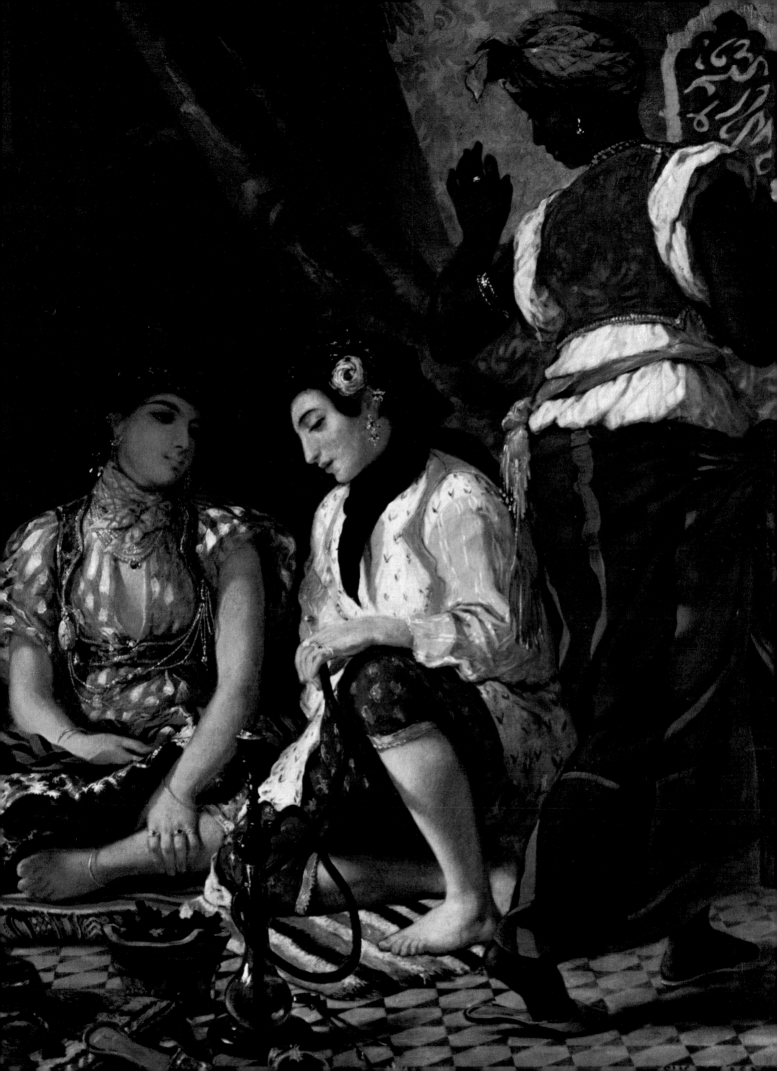

WOMAN OF THE EAST: FOR DELACROIX THE MYTH OF A THOUSAND FACES

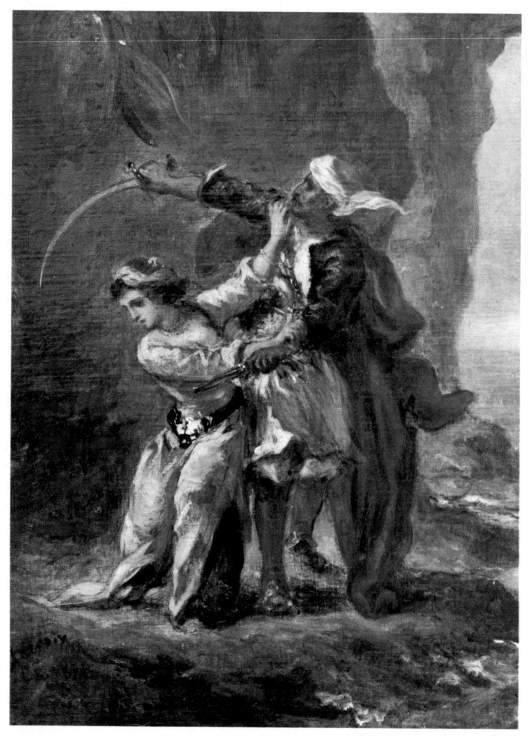

Delacroix pursued the myth of eastern woman for a long time, and portrayed it in many guises: in his Rebecca (1846), Aspasia (1826), Aline, the mulatto woman (1824), and even Mme Villot, his friend's wife, whom he painted in Moorish dress. His most dramatic rendering of this theme was a work entitled "The Bride of Abydos" (left), in which Byron's heroine Zuleika dies after seeing her father kill Selim, her lover. Above: "Arab Players and Jesters" (winner of a medal at the 1848 Salon).

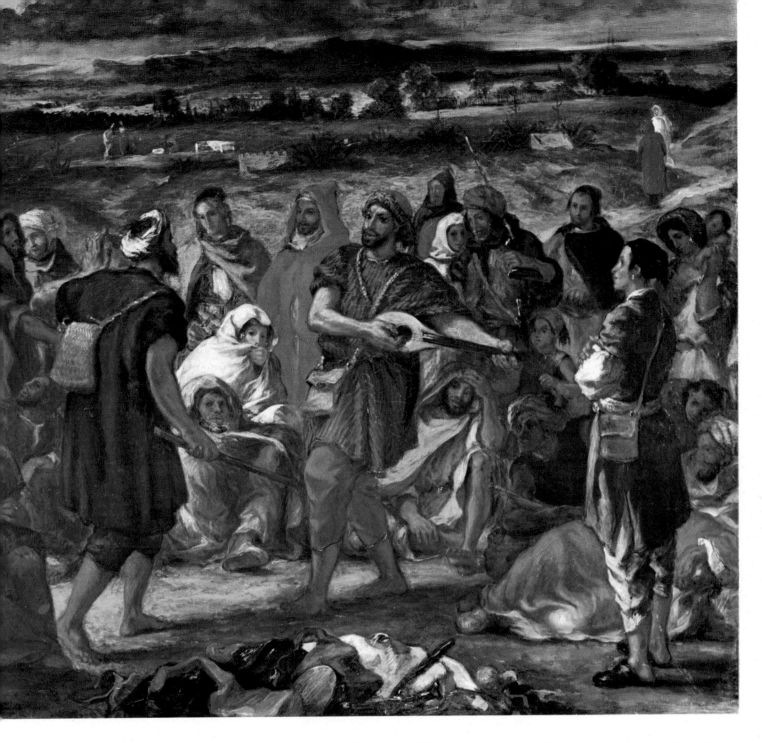

"The women of Algiers are famed for being the most beautiful along the Arab coast. They enhance their natural grace with richly woven clothes, shimmering silks and gold-embroidered velvet. Their skin is of an unmatchable whiteness. Those with fair hair dye it black, and they accentuate the natural black of their hair with henna and adorn their locks with roses and jasmine. After one has passed through the dark corridors and arrives at that part of the house reserved for the women, one is suddenly dazzled by the vivid light as fresh-faced children and women appear in a cascade of gold and silk. For a painter it is indeed a moment of irresistible enchantment." Delacroix must have experienced this moment of magic recounted by Charles Cournault, curator of the museum at Nancy. In 1832 it was almost impossible to obtain permission to enter a harem. The only artist to do so had been Melling when he painted Hadidie, the beautiful sultana, unveiled. English tourists and artists visiting Algiers were content merely to sketch the old quarters of the city. But what was good enough for the English simply would not do for a French painter. Delacroix, one of whose paintings had greatly pleased the harbour-master of Algiers, was given permission to make sketches in that official's own harem. Dressed in his little peaked cap, he visited the place secretly and found once more the beautiful women he had portrayed in his "Death of Sardanapalus". These he reproduced for the wonder of succeeding generations, and even recorded their names. The woman leaning on her elbow and "listening to the sobbing of the fountains" is Morim. Bahya, a rather sad Muslim girl of Turkish stock, is next to her, and beside her is Zohra. Later, in his painting of Zuleika, a heroine taken from Byron, the eastern woman of Delacroix assumed a more legendary character.

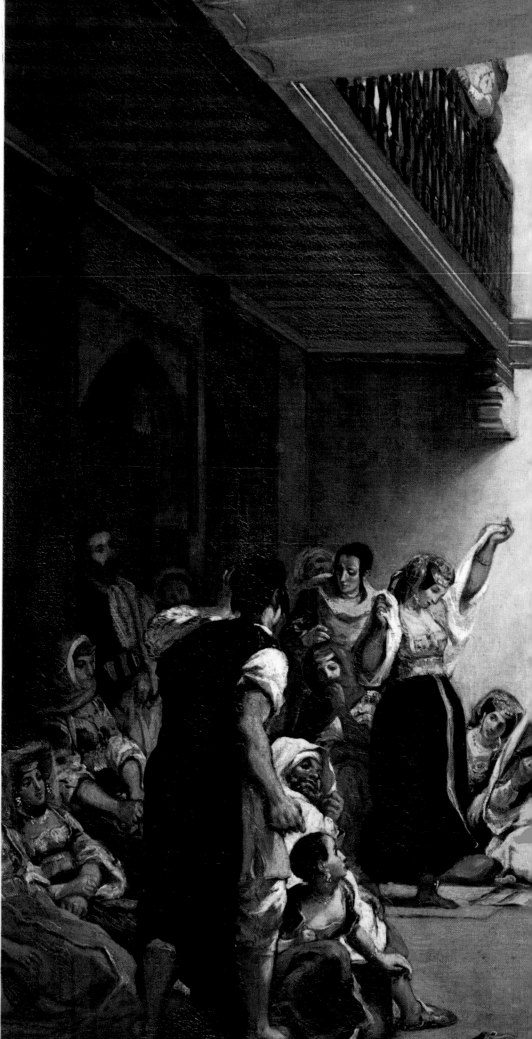

*"A graceful young Jewish girl,
wearing a gold-coloured bodice,
is standing by the violin player:
she is framed by the door in the
middle of the wall. The shadows
around her are deepened, but in
them I can see reflections of white.
Two Jews are sitting on a step,
their noses reflecting light. Another
Jew is standing in the doorway, his
clear, sallow profile sharply focused
against the wall. There is an old
Arab wearing a shaggy burnous . . ."
Delacroix made these notes in
Tangiers during a wedding feast
on February 22, 1832. Ten years
later he wrote an article based on
them for the* Magazin Pittoresque.
*"Alas, I shall bring back but a
shadow of everything I have seen,"
he wrote at the beginning of his
journey to Morocco. But his
notebooks with their sketches, in
which it is difficult to tell where
his pleasure in writing ends and his
pleasure in drawing begins, do not
support this statement. The wedding
which he attended is recorded in
his painting "Jewish Wedding in
Morocco" (right), now in the
Louvre. The painting, with its
subtle geometry, seems to
foreshadow the works of Mondrian.
It was exhibited at the 1841 Salon.
Above: a study for this painting.*

40

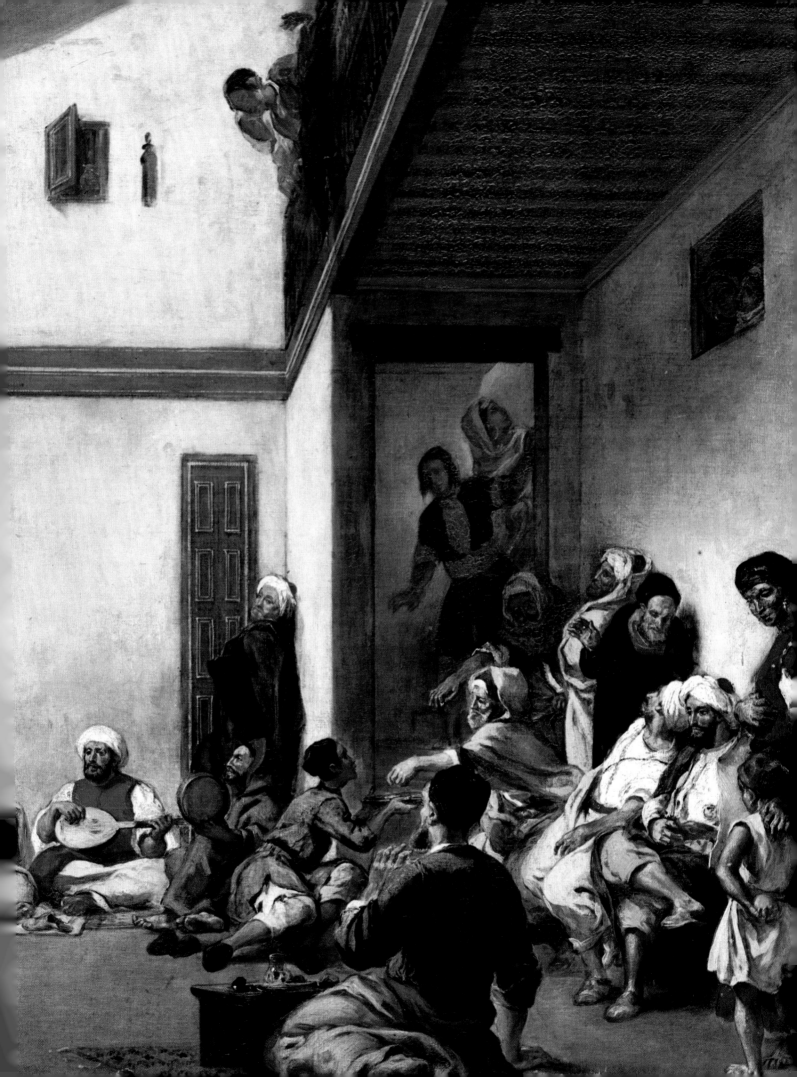

Charles de Mornay was a young man given to wearing dressing-gowns in the Eastern style. A painting of him by Delacroix catches exactly the flavour of Dandyism. In 1832 de Mornay was entrusted with a diplomatic mission to the Sultan of Morocco. On the advice of the actress Mlle de Mars, he asked Delacroix to accompany

him. Throughout the voyage, during which they visited Tangiers, Oran, Algiers, and many other cities, the painter filled his sketch-book with an endless variety of subjects. The Arab battle-scene (right) was painted many years later, in 1863. With its strong diagonal perspectives, this painting is characteristic of his Late Period.

AN AFRICAN THESAURUS

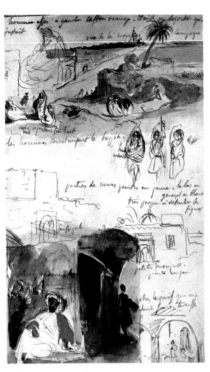

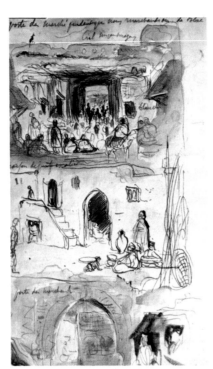

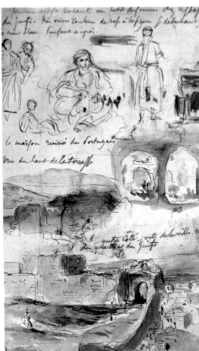

Delacroix's visit to Morocco in 1832 marked a turning-point in his career. He himself referred to it as "my road to Damascus". Here, beneath the blazing African sun, he finally abandoned the Romantic vision of the East which he had shared with Hugo, Byron and Rossini. "The pink-limbed heroes of David and company," he wrote to Villot, "would cut a very sorry figure here, next to these children of the sun." The visit lasted a bare six months, from January to June; but in that time Delacroix managed to fill many sketch-books. This strange new environment fascinated him, and at times almost overwhelmed him with its abundance of riches. But the great achievement of Delacroix's visit was the re-discovery of what he termed his "sources". This is not to say that his African experience converted him to Realism. The essence of his art was the careful re-creation, after much reflection, of the natural order of things; and the School which talked of "the cruel reality of objects" had always been repugnant to him. What Delacroix did learn during his stay in Africa was the value of pure colour—that is, colour liberated from any restrictions placed on it by rigid form. He discovered also that the lands of the sun stimulated an art-form which rejected clear-cut boundaries and which, unlike Western art, was not forever seeking to define and make precise. It was an art which sensed Nature, and submitted to it; and in doing so, in letting itself be taken over by impressions and colour, it seemed to have the effect of exalting the whole of life. Under this profound influence Delacroix himself took on a new lease of life. He now found himself able to abandon many of the Romantic tenets to which he had hitherto clung, and he began to repudiate his former "masters". He accused Goethe, to his face, of being "turgid"; and he scoffed at Byron for his flamboyance. It might be said that these rebukes were also directed against his own earlier works; for although it was many years before the fruits of Delacroix's visit to Africa were to be seen in public "The Algerian Women", when it finally appeared, showed none of the imported Orientalism which was such a characteristic feature of Romantic painting and which is so readily recognized in Delacroix's own "Sardanapalus".

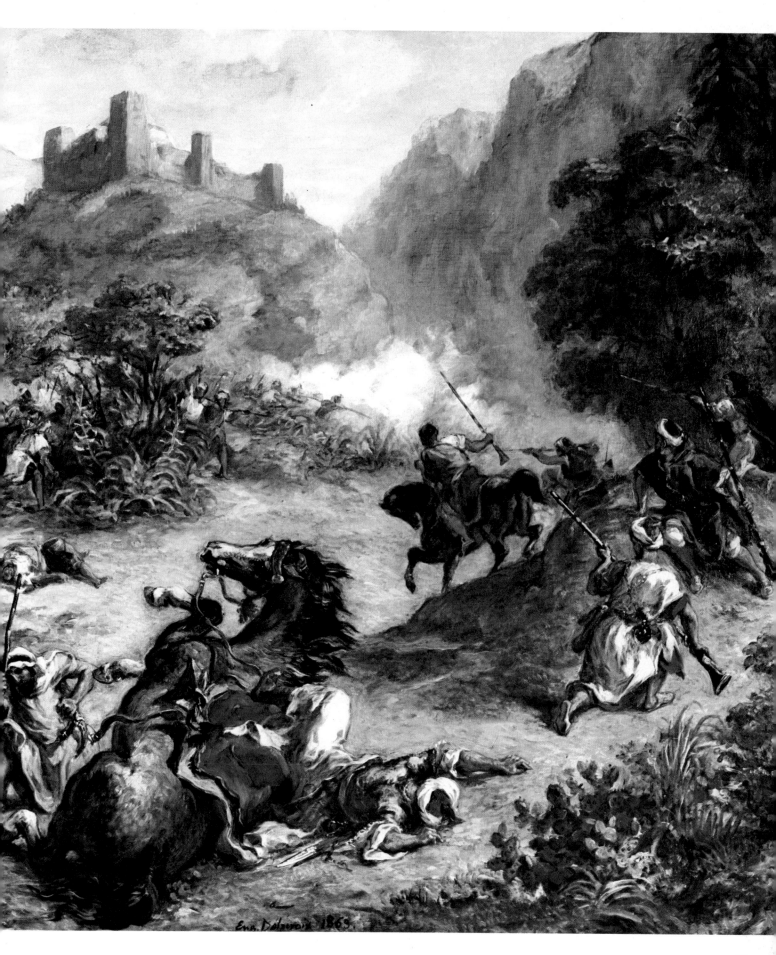

Eug. Delacroix 1863.

43

THE TERRIBLE HYSTERIA OF FANATICISM

"The day we arrived in Meknes there was a great hubbub and more gunfire than is ever heard in any battle fought in this country. The Sultan had ordered (under the severest penalties) everybody to shut up their shops and enjoy themselves with festivities until the morning." Delacroix's letter describing their arrival was written on 2nd April 1832. His painting of the Sultan with his parasol and bodyguard was done in 1845. Delacroix also recorded the wild Arab welcome which greeted the French visitors in his "Arab Fantasy" of 1833. This painting catches the frenzy of men and horses in a composition of horizontal bands of light broken by the perpendicular of one horseman triumphantly holding his carbine aloft. The welcome was not without its alarming moments: "They fired off their guns almost in our faces." There was also tedium. The celebrations began in the morning and by four in the afternoon there was still no sign of anyone sitting down to table. Delacroix saw much in this country which would have given the doctrinaire socialists of Saint-Simon "a great deal to talk about concerning the rights of man". But at every step, the artist found "pictures that would bring glory to generations of painters". Delacroix used bribes "to get to know the ways of the people better". Sometimes he was successful, but at other times he was met with a brooding hostility. Once he was nearly stoned and he turned on his would-be attackers, calling them "Infidel dogs" and "Beggars". He was also saved from being stabbed by an escorting official. It was in the Casbah of Algiers that he witnessed an explosion of religious frenzy which provided him with one of his most realistic paintings.

"The Yassoui excite themselves
with prayer and frantic shouting and
then walk over burning coals,
twitching like galvanised frogs . . ."
Delacroix captured the scene in
this painting of which Gautier said:
"The warm, light colour softens
everything repugnant and frightening
which the scene could have
presented." The painting is in the
Toronto Art Gallery.

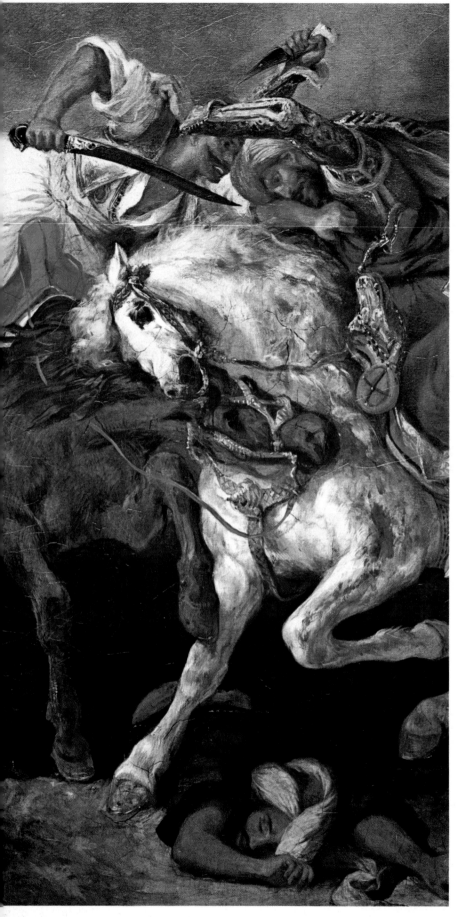

THE ACCURSED GIAOUR, TORN BETWEEN GOOD AND EVIL

Byron died at Missolonghi in 1824. He was already a myth: he was a beacon, as Baudelaire said, which looked from afar at the spirit of the age. In his youth Delacroix had noted in his diary "To fire yourself, think of some of Byron's passages . . . I feel the verses like a painter". Twenty editions of Byron's work were published in France between 1818 and 1847. *The Giaour*, dedicated to Goethe, appeared in 1813. The Giaour was one of Byron's doomed heroes, a sort of turbaned Manfred, a man destined to prove fatal even to the people he loved. Jaloux wrote: "It is Byron who has given youth the taste for believing itself cursed." He was, indeed, the source of a whole series of romantic heroes, successors to the Italian Schedoni. The Giaour was the indirect cause of the death of Leila, the woman he loved. He swore vengeance but having accomplished it became conscience-stricken. Delacroix dedicated three paintings to this man torn between good and evil. They were shown in 1827, 1835 and 1850. In the last two of these, both painted after his voyage to Morocco, the sense of reality manifest in the colour and in the character portrayal still does not overwhelm the poetic atmosphere of the subject.

Below: "Giaour and Pasha Fighting" (Louvre). Left: A preparatory sketch for the painting. On page 46: two other versions of the subject, which is taken from Byron. "A very great quality in Delacroix's talent, that which makes him the poet's favourite painter." Baudelaire said, "is that his style is essentially literary, and that accounts for his success in depicting the great literary themes of our time and for the broadness of his vision. He has translated, and is familiar with, Byron, Dante, Ariosto, Scott and Shakespeare." (Delacroix was also an excellent writer and an accomplished art critic.)

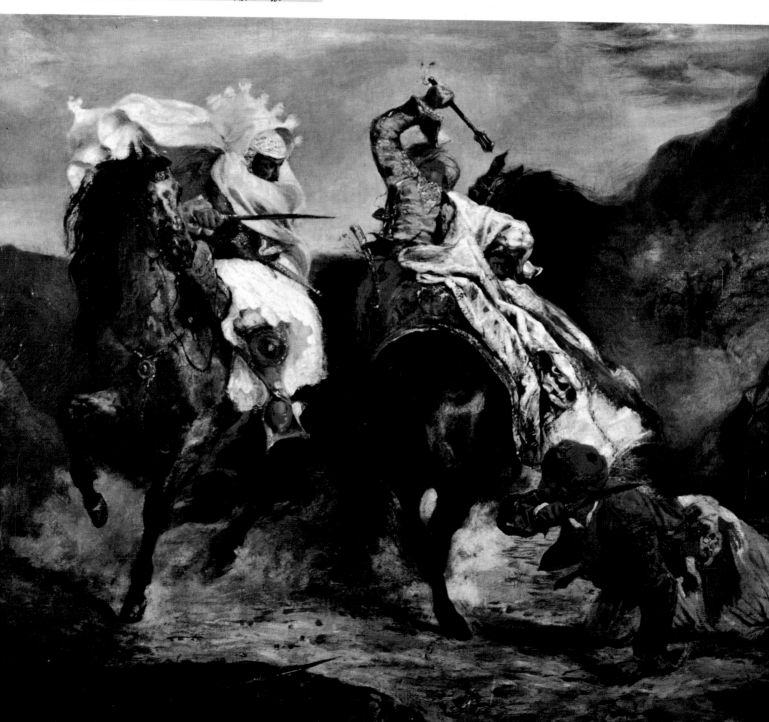

HE PERFECTS HIS WATER-COLOUR TECHNIQUE IN ENGLAND

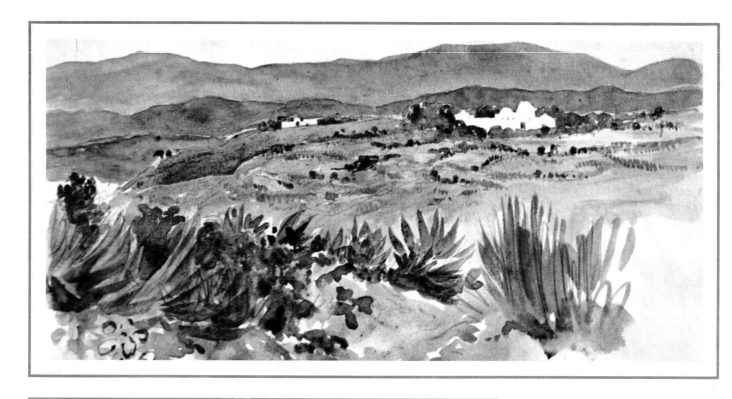

Above: "Landscape near Tangier", and left: "Landscape", two water-colours by Delacroix, now in the Louvre, as are the others shown in the following three pages. The fashion for landscape painting was launched by Chateaubriand in his celebrated Letter *written in Norwich, where he had gone in 1795. The letter became holy writ for Lami, Monnier and other French artists.*

Delacroix's friend Soulier introduced him to the technique of water-colour which was to make his brush-strokes so much more vibrant and limpid. Soulier, English-educated, also taught Delacroix English. "Dear Raymond," Delacroix wrote to him in 1850, "I never go past the Place Vendôme without looking up at 'our'

window . . ." The art of water-colour had been born in England at the end of the previous century. Subsequently, the works of Turner, who was a friend of Delacroix in Paris, and Bonington served to make it popular throughout Europe, and in 1852 Delacroix went to England to perfect his water-colour technique.

Above: "Landscape in the Pyrenees", and left: "English Landscape". Delacroix discovered in England "all Soulier's landscapes". He was flattered by the high opinion that Lawrence, celebrated portrait painter and dandy, had of him. English music, however, was less to his taste: "If John Bull does not hear trumpets throughout, he thinks the orchestra has gone to sleep."

AN ENDLESS
DIALOGUE WITH
LAND AND SEA

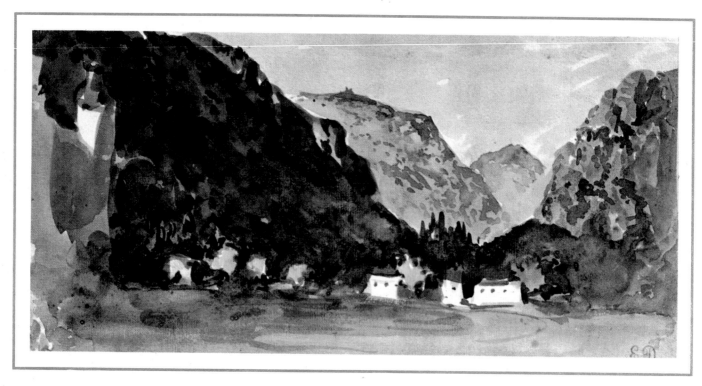

*Left: "Landscape near London"
(1825), a water-colour. In England
("It is untrue that 'goddam' and
'one shilling, sir' are the basis
of the language," he wrote.)
Delacroix went in for sport. "I
have often seemed to be running
the risk of breaking my neck
riding, but all this helps to form
the character."*

The Atlantic shining in the Bay of Algiers under a "rare sun", caught Delacroix's eyes as he disembarked in Morocco on January 24, 1832. He loved the sea: seascapes, such as those done at Tréport, Dieppe and Trouville, were parts of the endless dialogue he conducted with the sea. From Dieppe, in 1854, he wrote to Mme de Forget: "I feel more of a man outside Paris. In Paris I am just a gentleman. . . . I have a small stove, like the one you have, and I passionately cook myself pancakes, prawns and oysters. Afterwards I go down to the mole to watch the ships coming and going." Below: "The Bay of Tangiers". Above, opposite page: "Mountain Landscape".

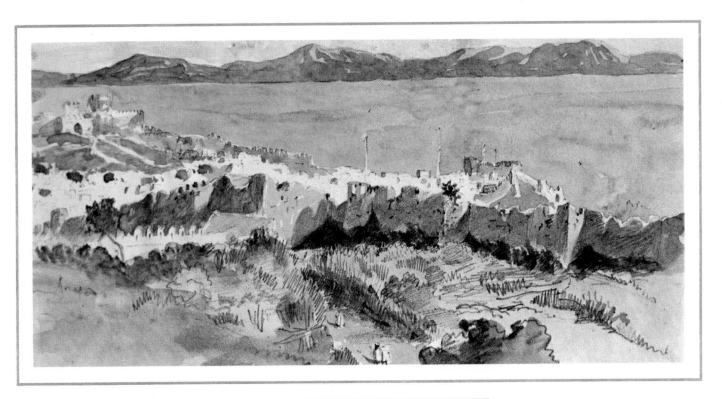

Left: "Pyrenean Landscape". Delacroix spent part of 1845 in the mountains after an attack of the tubercular laryngitis which was finally to cause his death in 1863. When he was in the country, as he often was, he sought relaxation from the arduous life of Paris, which he described as "an endless dance on a tightrope".

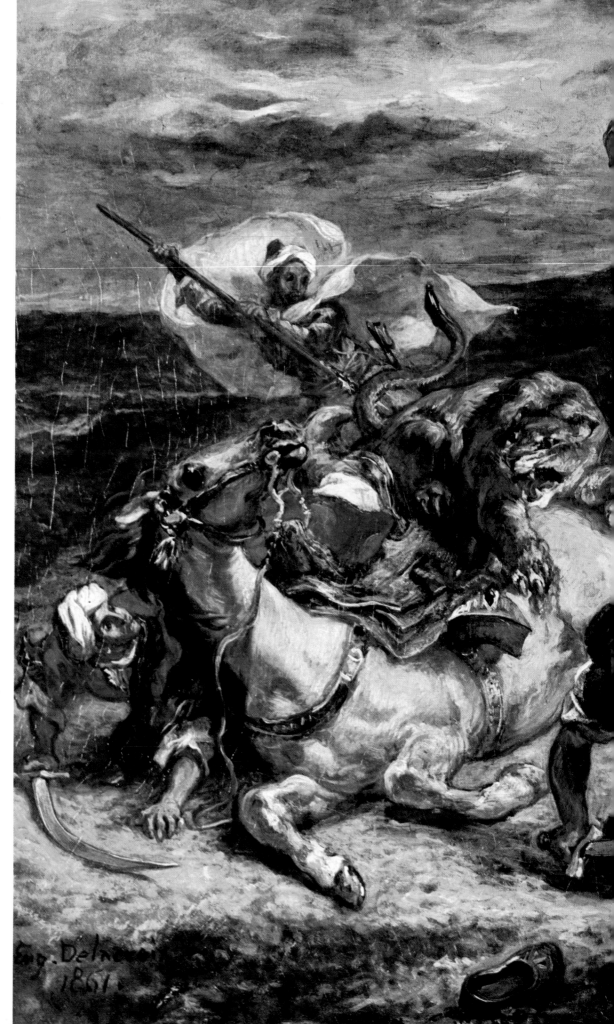

This "Lion Hunt" of 1858, now in Chicago, is evidence of how much Delacroix borrowed from Rubens. Baroque art reacted against the serene harmony of Classicism by portraying a passionate vitality, which can be seen in this remarkable work in the writhing of the men and animals and in the rotating movement of the composition.

52

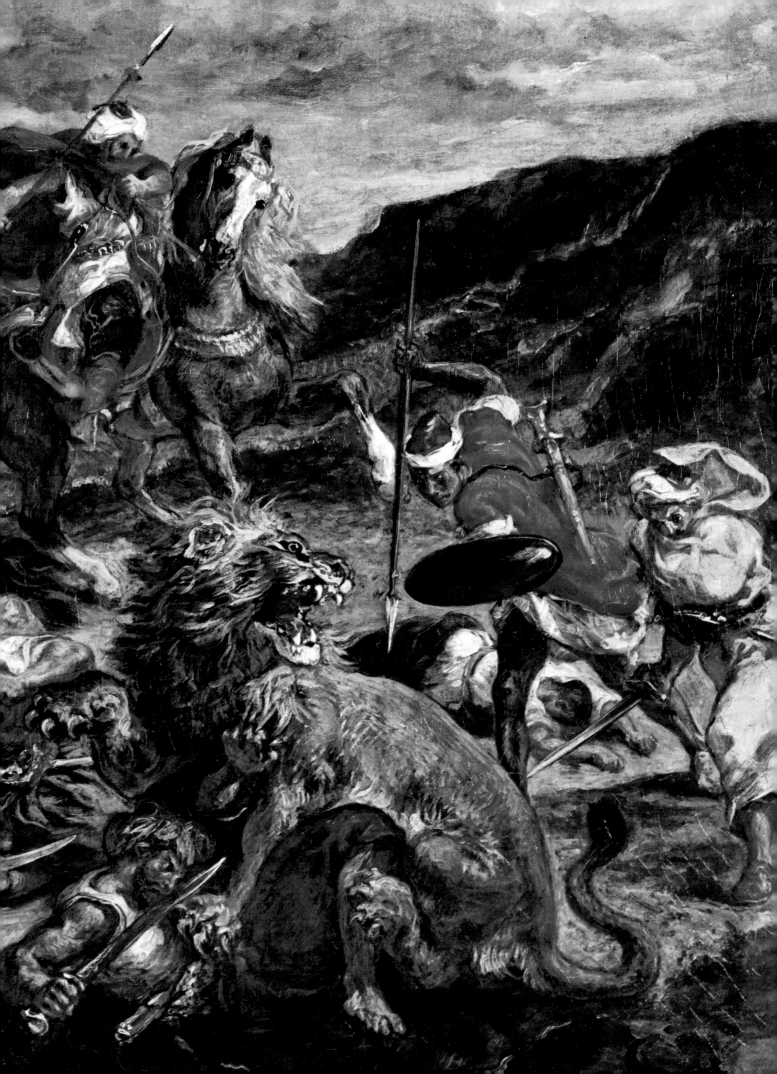

THE BEAUTIFUL CRUEL WORLD OF DELACROIX'S WILD ANIMALS

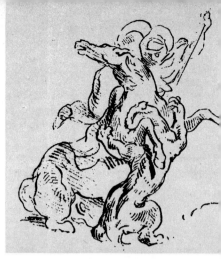

". . . Tigers, panthers, jaguars, lions . . ." This entry in one of the pages of his *Journal* suggests Delacroix the writer seeking a phrase to express what was for him a passionate obsession. More than any other animals these fascinated him and he studied them at the Jardin des Plantes, to which he went regularly in Paris. It was there in 1847 that he resumed his *Journal* after a break of several years. His friend Cuvier, the curator, gave him the freedom of the place. At the animals' cages he studied their ferocity and the instinct which united their agility and grace. Like Rubens, Delacroix was spellbound by the big cats. He drew them both from life and from memory and imagination—his lithograph of a tiger was done long before he went to Morocco. He portrayed them lurking, sphinx-like, in some oasis. He never tired of these beautiful, cruel beasts which, as hunters or hunted, dominated his paintings in a way his women never did. He was fascinated by their fighting instinct, and by the way in which they sprang upon their victim. His friends even saw something feline in the artist himself. Gautier wrote: "He had tawny, feline eyes, with thick arched brows, and a face of a wild and disconcerting beauty; yet he could be as soft as velvet, and could be stroked and caressed like one of those tigers whose lithe and awesome grace he excelled in portraying." Certainly he was exceptional in that, beneath his outward reserve, he was fully aware of the beast in man. Perhaps deep inside him he aspired to the state of the wild animals; certainly his passion for depicting animals fighting betrayed his burning lust for life. (He painted a hunting scene in 1855 to match himself against Ingres at the Universal Exhibition that year.) There is something here of the Jekyll and Hyde dichotomy. Delacroix was not the sort of man to indulge in open rivalries or to act in a mean way. Extremely reserved, he was highly vulnerable in the battle of life. Aware of this, he expressed his will to fight in his painting, and through its images he projected all the obstacles that confronted him, as well as the conflicts that raged within him. In doing this, he was both actor and director. By re-creating the conflicts in his soul, he found his freedom from them. Perhaps this is the key to the enigma of the man.

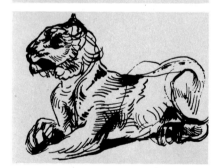

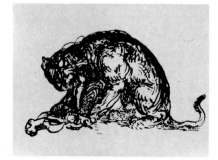

Below: "The Tiger Hunt" (Louvre). Painted in 1854, it was shown at the Salon the following year. The anatomy and psychology of wild beasts seem to have had no secrets for the artist, who was constantly studying and making sketches of them for his hunting scenes (left). Endlessly excited by their grace and disciplined strength, he returned time and again to the actual animals, recording every detail and elegant movement. He found his subjects in the animal enclosures of the Jardin des Plantes, (where he often went with Stendhal) and he also came across many fine specimens in Africa, where he was able to observe them in their natural surroundings. In an annexe of his country home at Champrosay the artist kept a large number of cats, and these he used as models in his constant study of the cat family. They might well have been those same cats that Baudelaire described as "the strong, sweet pride of the home which seem to sleep through a never-ending dream".

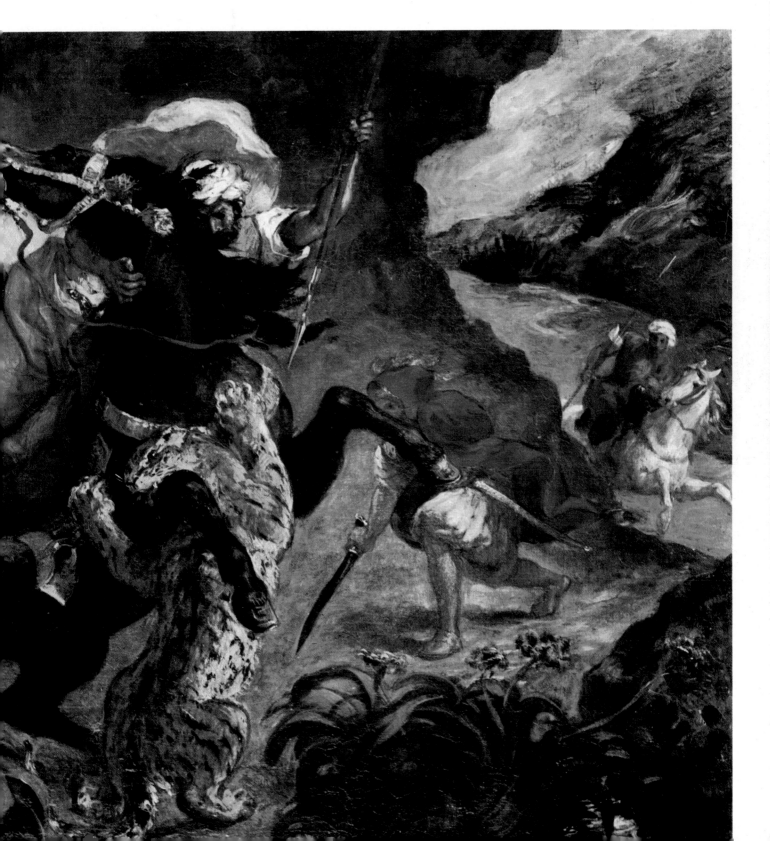

THE TERRIFYING SCENE THAT WON HIM THE LEGION D'HONNEUR

"A terrifying confusion of lions, men and horses . . . a chaos of claws, swords, fangs, lances, torsos and backs in the manner of Rubens." These are the words in which Gautier described *"The Lion Hunt".* This painting was shown at the Universal Exhibition of 1855, and it won its creator the award of Commander of the Legion of Honour. Ingres, who exhibited a stiff and starchy Joan of Arc, was made a Grand Officer of the Order. Both painters were chosen to represent French painting at the Exhibition. *"The Lion Hunt"* was partially destroyed by fire in 1870. It was restored, and it may now be seen at the Musée des Beaux Art, Bordeaux.

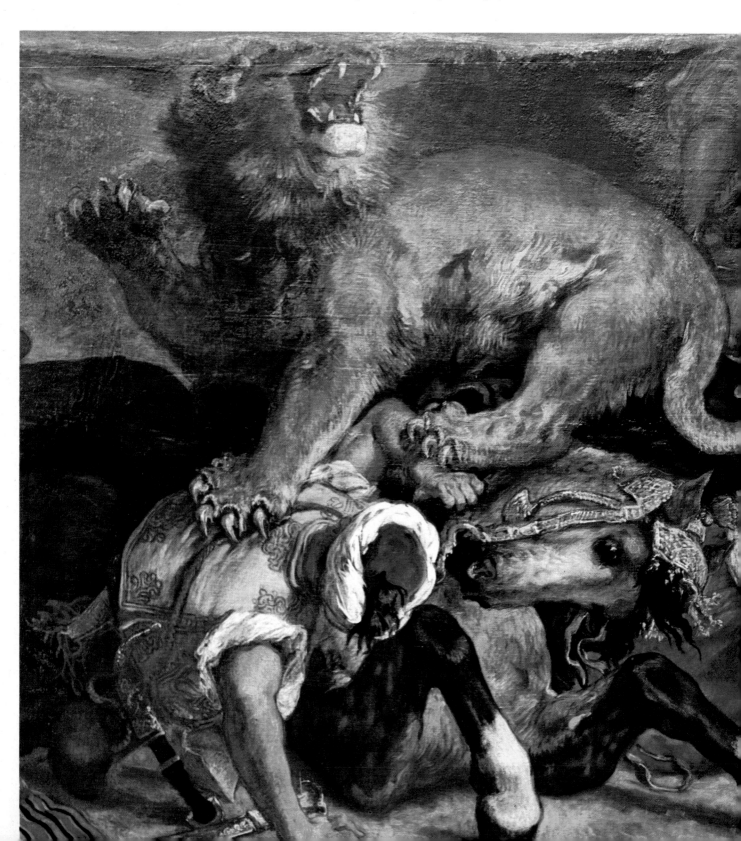

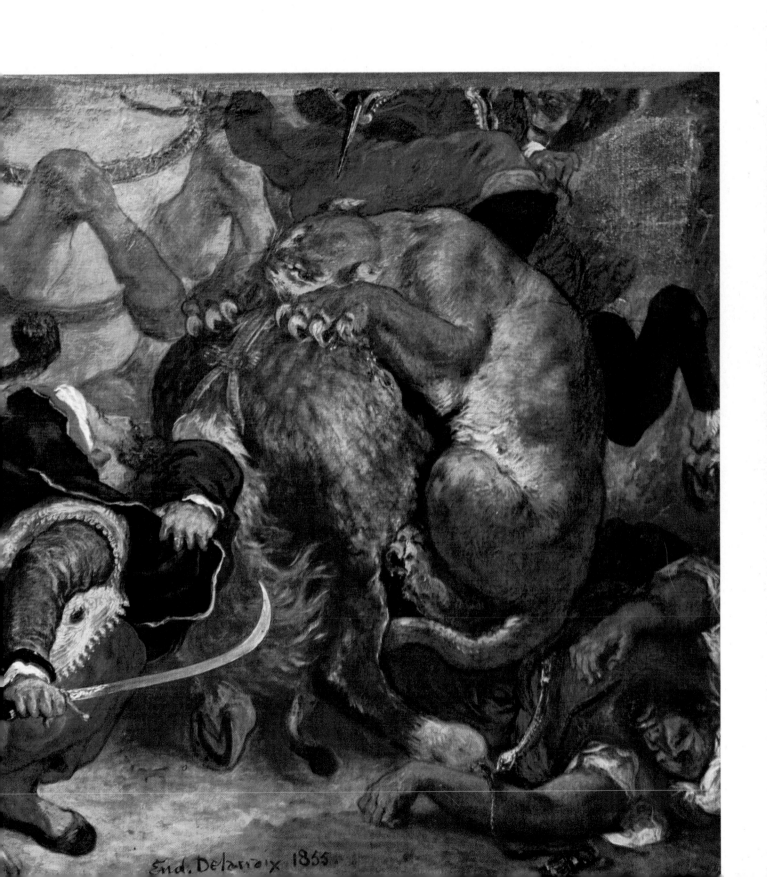

Eug. Delacroix 1855

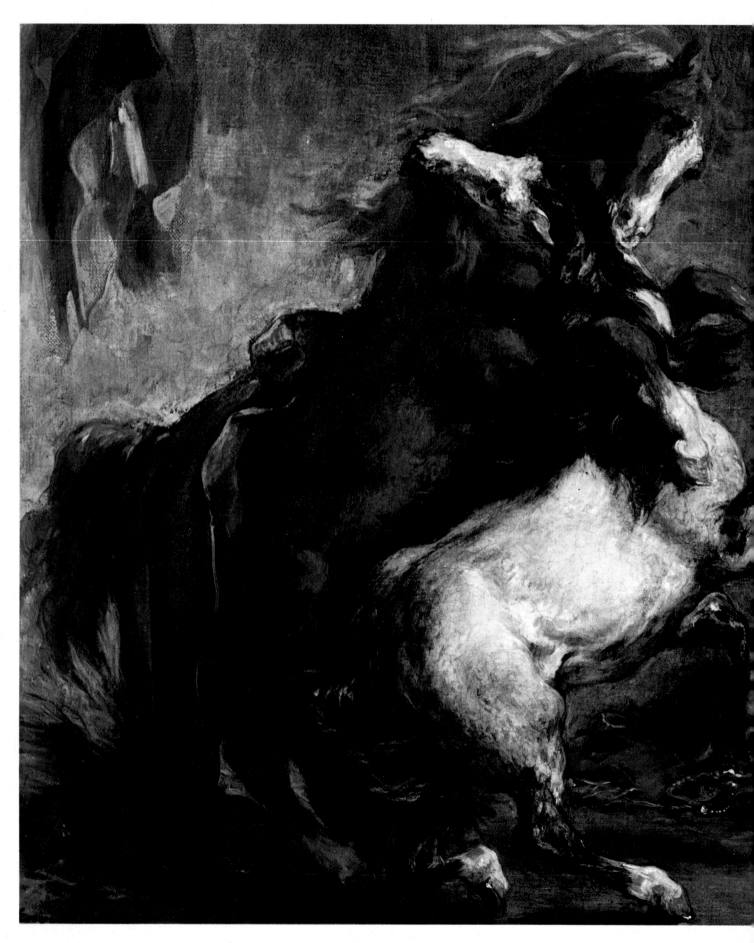

58

THE HORSES OF ROMANTICISM GALLOP ON TO THE SCENE

Delacroix often used horses to express conflict. Opposite: "Horses fighting in a Stable" (Louvre). Below left: "Horses Coming out of the Sea" (Washington, Philys Collection). Below right: "Dead Horses". Bottom: "Horseman in Armour" (pen and wash, Cleveland Museum of Art).

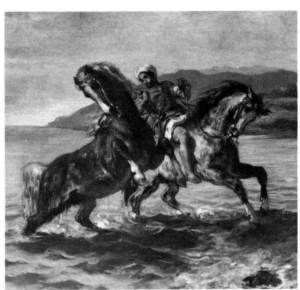

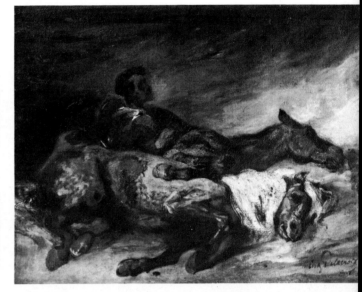

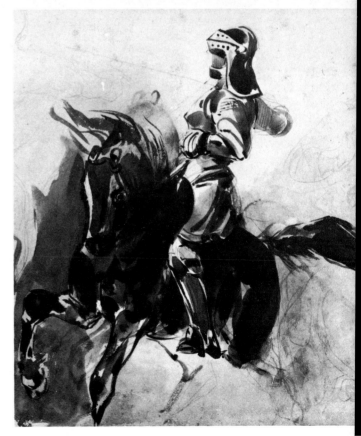

"I shall never rid my mind of Attila and his horse," Delacroix exclaimed while painting "Attila and the Huns" in 1847. The horse to which he referred dominates a fresco in the Palais Bourbon, the seat of the French Parliament. If the painter himself was deeply affected by it, all Paris was talking about this unstoppable white stallion, one of its hooves raised as if to deny the conquered any pity. The horse was to be adopted as a symbol of Romanticism. Its galloping rhythm cropped up in the music of the time, a symbol of uninhibited drive and force. Delacroix had started to paint horses during his stay in England in 1823, when he had lodged for a while with a Mr Elmore, a horse-dealer. Delacroix's horses are the swift, fiery-eyed steeds eternally galloping through his dreams, carrying sombre heroes, like the Giaour and Faust, to some inescapable abyss. They are the horses he saw in Tangiers about which he said: "Even what Gros and Rubens conjured up to depict the Furies was nothing compared to these animals." They are the horses coming out of the sea, the heirs of a primordial innocence and virginity. They are the winged steed of Roger the knight and the vengeful team of Apollo. "But no-one," said Delacroix, "has understood and painted horses like Gros."

DELACROIX FREES DRAWING FROM THE BONDS OF CLASSICISM

Ingres and Delacroix once found themselves at a dinner given by a banker in honour of the leading French painters of the day. Throughout the meal, Ingres kept looking angrily at Delacroix. When the coffee was served, Ingres finally exploded. He went up to Delacroix and said: "Drawing, sir, drawing! It means honesty in art. It stands for honour." Ingres was shaking so much that he spilled his coffee all over his waistcoat. Then he stormed out of the room, declaring: "I cannot allow myself to be insulted a moment longer." Delacroix remained silent throughout. This incident demonstrates the extent to which the two Schools differed as to the value of drawing. Delacroix's sin was that he had rediscovered colour and had abandoned the old Classical dogma of "line above all else". He expressed his own view thus: "Nature has no precise contours. Its essence and its mode of existence is light. This is constantly breaking up outlines. It does not delineate an object on a flat surface, but shows things in the round . . . The pupils of Ingres want to change Nature. They turn their subject into a flat surface with well defined edges and, so that there can be no doubt about their intentions, they even use Chinese shading and flat colours . . . I admit that it is a way of simplifying Art. But there is a better way: do nothing at all."

Delacroix's contemporaries accused him of neglecting drawing. This was scarcely a justifiable criticism of a man who used to tell his pupils: "If you cannot draw a man who has thrown himself out of a window of the fourth storey by the time he has fallen to the ground, you will never be able to undertake a more important task." Delacroix, whom Cézanne called "French painting's most beautiful palette", felt bound to liberate the art of drawing from the rigid conception held by the classical school, typified by Ingres. Baudelaire said: "Delacroix's drawing has the tremendous merit of being a protest against the barbaric invention of the straight line." On these pages are some of Delacroix's drawings: on the right, a fishing port (now in the Cabinet des Dessins *in the Louvre); below: an Arab horseman; below right: a forest landscape and a view of the African coast.*

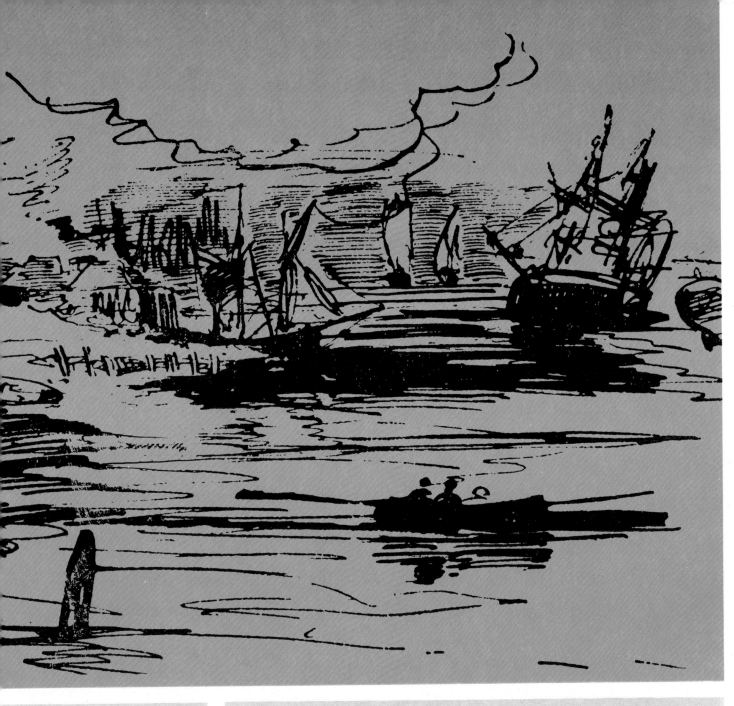

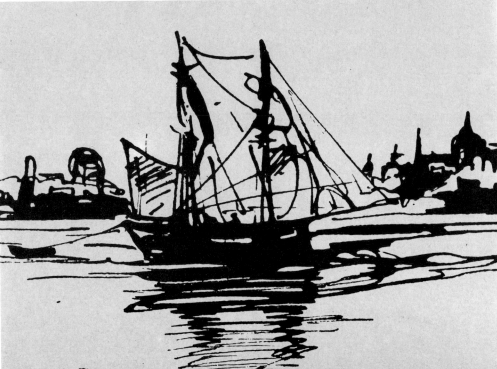

HE BORROWED FROM ALL BUT REMAINED A GREAT MASTER IN HIS OWN ART

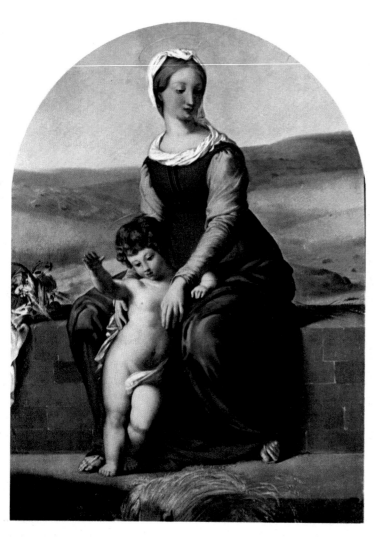
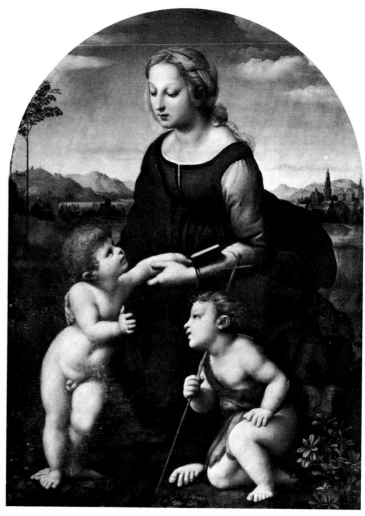

The young Delacroix admired the ease with which Raphael "conversed with the Gods". Later he turned against Raphael, perhaps because the Italian painter was the antithesis of Rubens and the spiritual father of Ingres. Instead, Delacroix was drawn to the great masters of the Flemish school, particularly Rembrandt, whom he preferred to "Perugino's studious pupil". Delacroix frequently made re-appraisals of his masters, including Shakespeare and Michelangelo. The exception was Titian, of whom he said: "If I were to live to be a hundred, I would still prefer Titian above all others. He is the least mannered and the most varied of painters." Because Delacroix constantly had recourse to the Old Masters—Michelangelo, Rubens, Titian

—at the same time as he preserved his own individual style, it proved difficult to classify him. Was he a Classicist? Or was he a Romantic? This was a question much debated by critics. One could paraphrase Wanda Lanowska on Chopin, and say that Delacroix was a baroque painter with a Romantic varnish. Or one could go to the other extreme and offer no definition at all. The truth is probably that this man whose romanticism coincided with the romantic period was simply an original; like all geniuses, he followed his own road. In fact, as Baudelaire very properly said, and Cézanne subsequently confirmed, he was a painter with no antecedents and no successors, who was yet an unbreakable and vital link between the past and the future of painting.

62

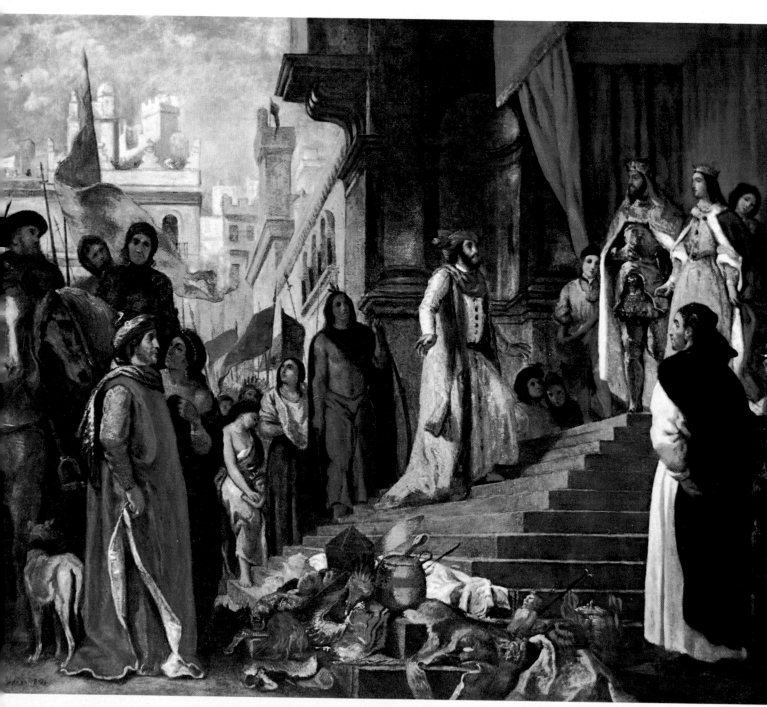

On page 62: "The Virgin of the Harvest" (in the church at Orcemont), painted when the artist was 21. He evidently based it on Raphael's Madonna, shown alongside. In his "Return of Columbus from the New World", 1839 (above), Delacroix repeated the geometric design of the "Jewish Wedding", but the most obvious analogy is with Titian's "Presentation of the Virgin at the Temple", below.

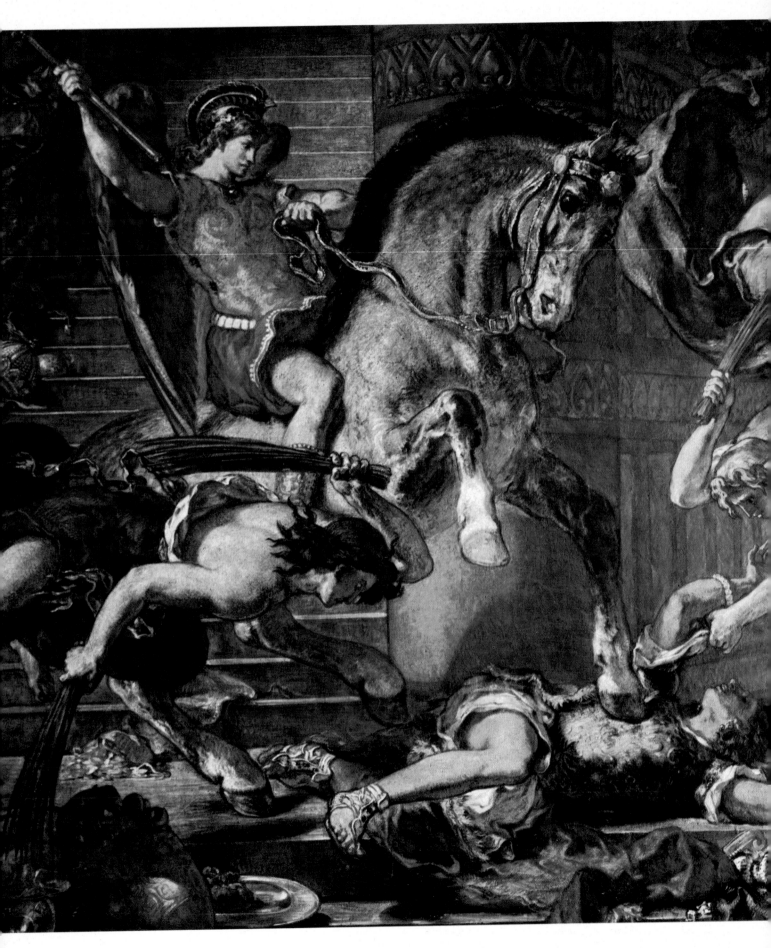

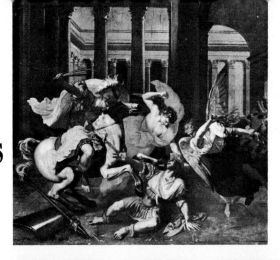

HIS DRAMATIC TREATMENT OF RELIGIOUS SUBJECTS OFFENDED THE PIOUS

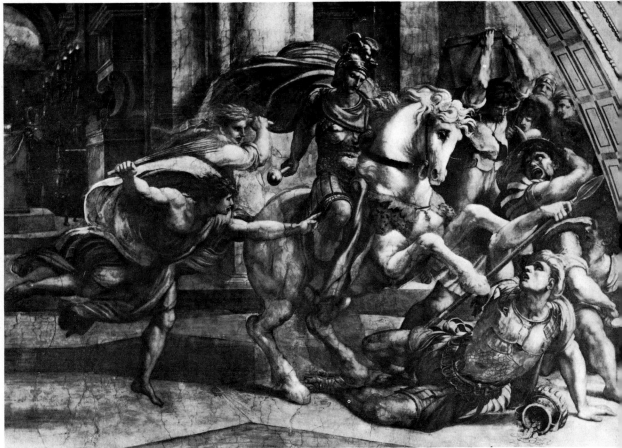

"All my illusions have left me one by one, only one happiness remains free from the bitterness of remorse: my work." During his last years, a period when he drew more and more into himself, he finished the frescoes for the chapel in St. Sulpice. He worked on these with complete dedication. "No monk could do more than I," he wrote to Mme de Forget. Though a sceptic, he was a great painter of vividly dramatic religious pictures. In them he tried to echo the suffering which Man expresses to God in supplication and prayer. In 1861, his frescoes in St. Sulpice offended the champions of Gothic Art, as well as those who preferred a less demonstrative religious art, and he came under harsh criticism from the *Gazette des Beaux Arts.*

On page 64: "Heliodorus expelled from the Temple", one of the masterpieces from the St. Sulpice frescoes, painted between 1849–61. The Bible relates how the sacrilegious Heliodorus was driven back by the emissaries of Heaven and realised that a divine force resided in the Temple. Delacroix talked a lot about God in his later years. Perhaps he saw himself in Heliodorus. Above: the same episode interpreted by Raphael, now in the Vatican and (top) by Bertholet Flémalle (1614–77).

IN THE STEPS OF RUBENS' BAROQUE ART

"The horse of St. Louis of France is a blaze of light generated by the ardour of its rider," said the catalogue of the 1837 Salon of Delacroix's "Battle of Taillebourg", detail opposite, and shown complete below, left. The painting aroused much discussion and attention when it was first shown, and the Salon committee came close to rejecting it.

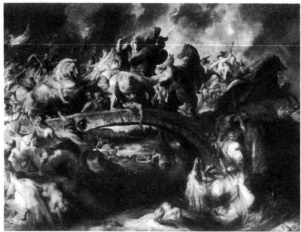

Holland was the birthplace of Delacroix's maternal grandfather, Jean-François Oeben, an eminent cabinet-maker who worked for Louis XV and was a favourite of Madame de Pompadour, and whose masterpieces in furniture are to be found in the Louvre. Delacroix went to Holland in 1839, taking with him his new young mistress, Elisa Boulanger. His object was not so much to visit the land of his forbear, as to acquaint himself with the paintings of Rubens, "the father of colour and vitality". With an amazing absence of modesty, he wrote to Pierret: "The nightmare of feeling myself annihilated by the works of the Flemish painters has passed. Like all of us, Rubens too had his moments of doubt and he sometimes imitated Michelangelo, Titian and Veronese." Delacroix returned to the Flanders of Rubens in 1850, just before he started his frescoes in the Louvre. This time he went alone and in a more humble frame of mind. It was a true return to his sources. He visited many churches, and made a special effort to see "The Raising of the Cross" in Antwerp. Of Rubens' masterpiece "Christ as Judge", he said: "It is impossible to outdo the inspiration and brush strokes of Rubens." From the Fleming he learned to express "the intensity of life"—to direct his efforts towards the translation on to canvas of the life-giving forces of Nature, and to reject the sombre imagery of the Romantics. Rubens had discovered these forces long before Géricault, Gros and Delacroix, and symbolised them in images

Rubens' "Battle of the Amazons" (above), in the Munich Museum, reveals one of the sources used by Delacroix. Rubens also inspired "Marin Faliero"; "The Ascent to Calvary" (St. Sulpice); "The Martyrdom of St. Sebastian" (1863) and "Medea" (1838). Gautier said of the latter work: "Rubens himself would not have disowned its élan *and fury."*

like that of a horse running wild before the wind (although for Delacroix, these forces tended to be of a nervous, rather than muscular, quality). And, in Baroque terms, they shared a talent for painting hunting and battle scenes. Delacroix admired Rubens in that he had seen the blood flow at the inquisitional courts of the Duke of Alba, and yet continued, unperturbed, to paint scenes from everyday life so strong that they amounted to a synthesis of life itself. The other great lesson which Delacroix learned from Rubens was the importance of the role that colour could play in art. (He was to perfect his technique with colour during his stay in Morocco.) The French painter wrote: "Look at one of Rubens' cherubs and you will see a rainbow of light which seems to penetrate the flesh and infuse the breath of life itself. You may truly say that Life overflows from the canvas."

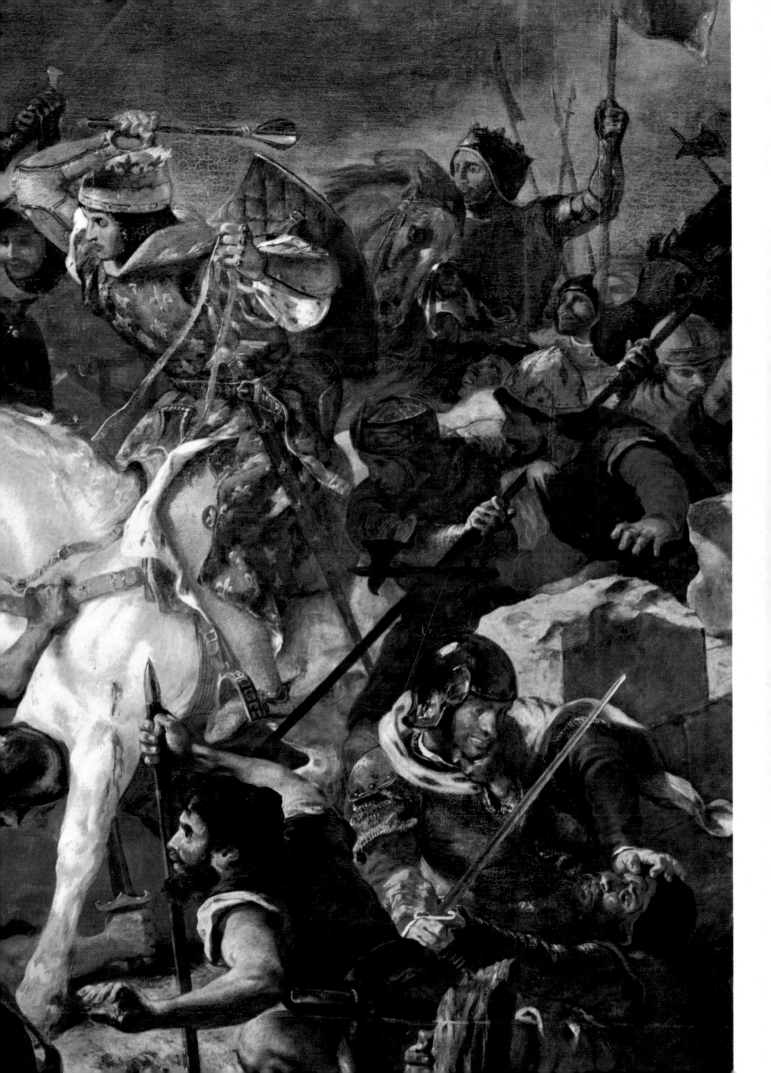

"Delacroix, a lake of blood, peopled by avenging angels, shaded by an evergreen forest of fir where, beneath a sombre sky, strange fanfares sound like stifled sighs of Weber." Baudelaire added his own comments to this verse description of his friend, Delacroix, painter of battle-scenes: "A poet has tried to express the subtle sensations suggested by one of Delacroix's canvases. The verse has been written with a sincerity that could lead the reader to the realms of the bizarre." Below: "The Battle of Nancy", 1834 (Nancy Museum). The dominant theme in this painting is the sense of defeat, of shattered hopes and of death. Victory was to be expressed later, in his painting of Louis of France, victor of Taillebourg. "Attila bringing back Barbarism to Ravaged Italy" (right), in the Louvre, also deals with war, a subject dear to Delacroix. The war theme is repeated in his Palais Bourbon frescoes (1838–47), to offset his painting of Orpheus bringing civilization to the Greeks.

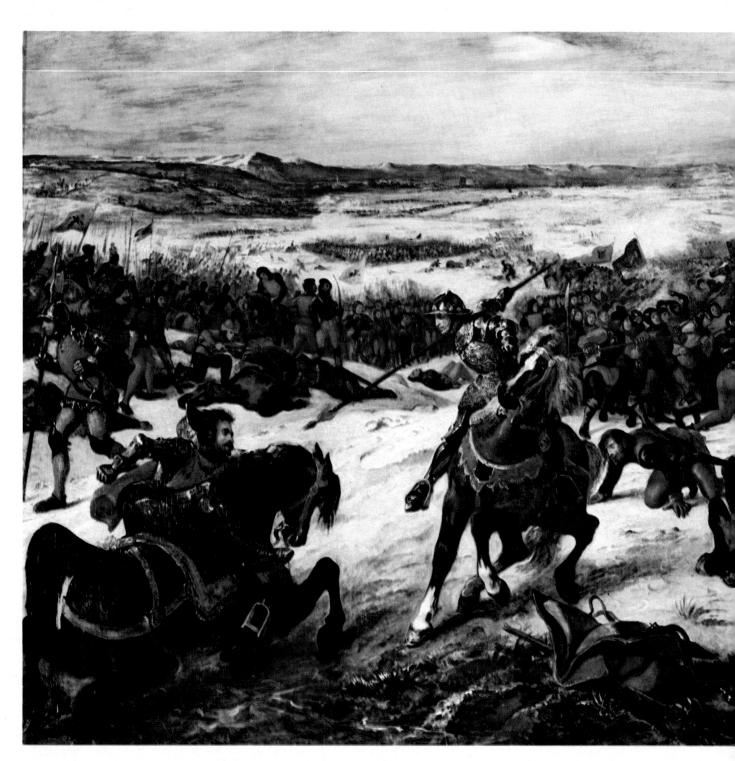

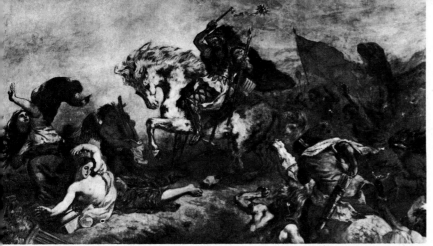

THE LAKE OF BLOOD

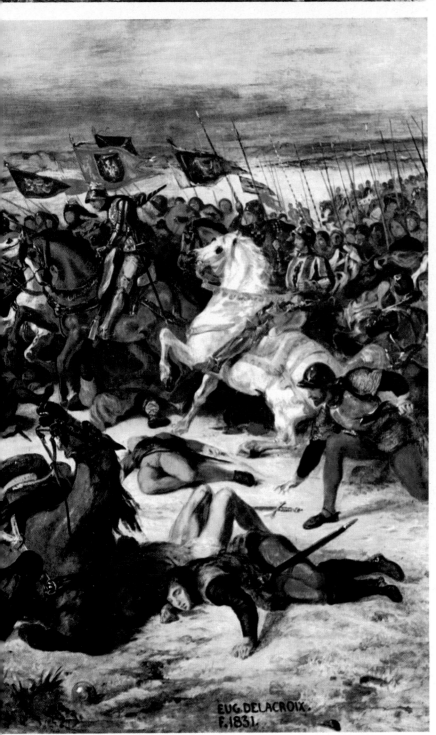

"A lake of blood" was how Baudelaire described Delacroix in his martial vein. He was a painter of stupendous conflicts, of men in action on a heroic scale. On his broad canvas their courage, their fury, their agony, all are larger than life—amid the carnage, oriflammes flutter in the wind, thrusting lances glint in the sun, hooves fly. The pageantry which Delacroix brought to his battle-scenes was indeed unsurpassed. In 1826 he had written to Soulier: "The Minister of the Interior, a competent man whom I respect, has commissioned a painting for the Museum at Nancy in which I am to depict the death of Charles the Bold." The result of this commission appeared in 1834. It was exhibited at the Salon that year, together with his "Algerian Women" and a portrait of Rabelais. "The Battle of Nancy" shows Charles, Duke of Burgundy, in the moment before he meets his death on the snow-covered plain. The painting is a mournful portrayal of the hollow triumph of Death, the only victor in battle. The snow deadens the cries of men and horses, and the whole scene seems like a moment of history which has been suspended and isolated, almost timeless, with the shadowy features of the plain fading into the unknown over the horizon. A very different atmosphere is found in his "Battle of Taillebourg": a heaving sea of men and horses, which has the same fierce energy as "The Battle of Poitiers", commissioned in 1831 by the Duchess of Berry. The sense of abject defeat which dulls the eyes of the Duke of Burgundy and his men at Nancy is not present in the Taillebourg painting. In that work, Louis, France's "Holy Monarch", has Victory by his side and Death is sent sprawling among the tangled bodies of the combatants. The rage of men and the glory of arms are the protagonists at Taillebourg. Delacroix worked on the painting during the summer of 1836, alternating with spells on a new project, "Medea". It was shown at the Salon of 1837, and immediately caused an outcry. Once more the artist had the sense of having been thrown to the lions by the critics, who seemed interested only in approving the fashionable conservative painters and in opposing innovation. His feelings were exacerbated by the fact that it was in this same year that his first application for membership of the *Institut* had been rejected.

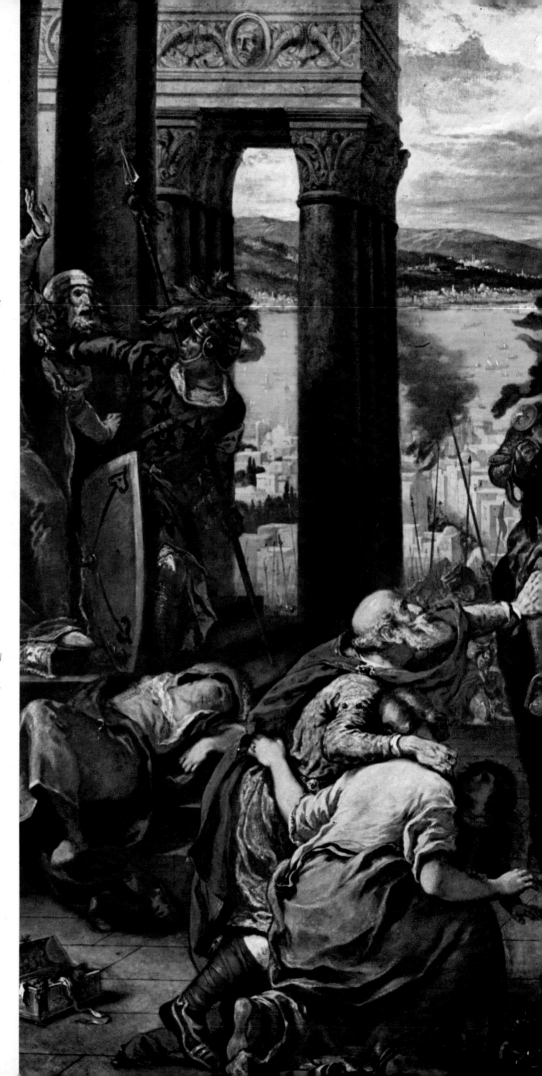

THE "FRIEND FROM VERONA"

"Have you read in the newspapers that the Minister has commissioned me to paint the frescoes in the Palais Bourbon? That is how I found out too . . . At present I am doing very little. I am like one of those generals who spend their time sleeping soundly before a battle. I am also engaged in a certain taking of Constantinople for Versailles, which means this is less than ever the time for me to lose my touch." Thus Delacroix wrote to a friend from Valmont in September 1838. The "certain taking" he referred to was the "Taking of Constantinople by the Crusaders" (right), which was exhibited at the 1841 Salon. After the battle comes this elegy for a victory; but this picture is also an allegory for the end of an empire. (Baudelaire described it as a symphony in violet major). The most striking feature of this masterpiece is that instead of the self-confidence born of victory shining on the faces of the Crusaders, they show bitterness and exhaustion, and thus are at one with the vanquished. Delacroix had used this theme before, but in the colder, more harsh and Northern despair of "The Battle of Nancy". The "Constantinople" also shows the influence of Paolo Veronese, Delacroix's "inimitable friend from Verona" of whom the French artist said: "He is a man who paints clear colours without violent contrasts and who can express space, something which was always considered impossible. Without exactly imitating his style, one can explore the avenues which his genius has revealed."

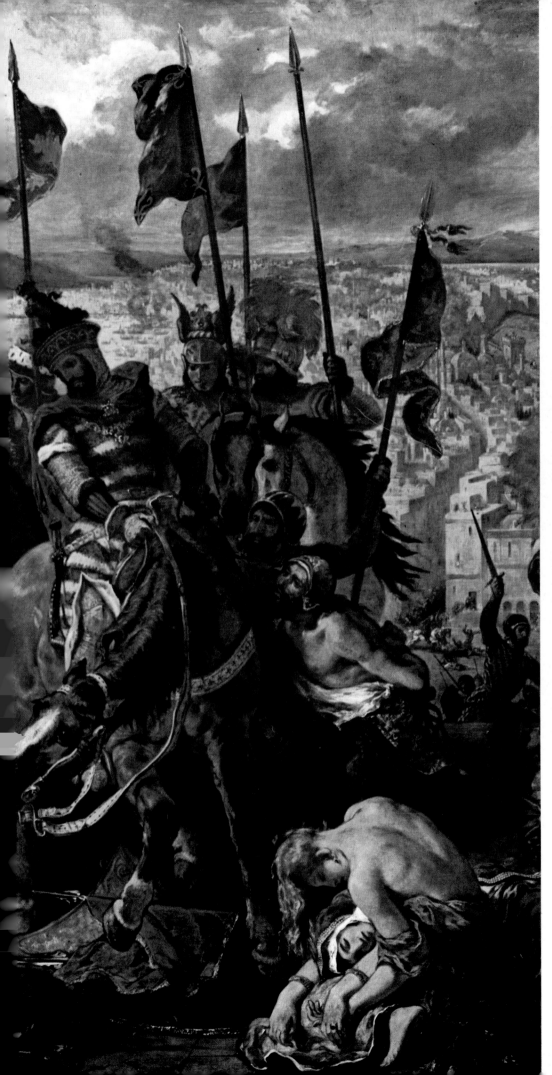

Delacroix's "Taking of
Constantinople" recalls Veronese's
"Jesus and the Centurion" (below).
There is also a similarity to the
"Surrender of Breda" by
Velazquez (below, centre).
Delacroix's self-portrait as Hamlet
(1821), was also in the style of
Velazquez. Bottom: Veronese's
"Martyrdom of St. Justine".

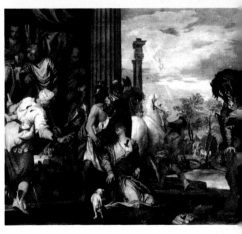

THE GOLDEN AGE OF MYTHICAL HEROES

Delacroix's frescoes in the Hôtel de Ville (1851–4) exalt, in the figure of Hercules, the use of strength for noble ends. The paintings were destroyed during the Commune rising and only the sketches remain (now at the Carnavalet). Above: "Hercules as a Child with Juno and Minerva" and "Hercules fighting the Hyrcanean Boar". Below left: "Juno and Aeolus", also known as "Winter".

Below right: "Spring". Right-hand page: "Diana surprised by Actaeon", also known as "Summer" (1862). The allegory of the four seasons (São Paulo Museum, Brazil), painted for the banker Hartmann, was considered by Delacroix to be the synthesis of his late style. The theme is Classical but it is interpreted with a freedom of gesture and inspiration which are completely romantic.

Having done with his doomed heroes, his desperate lovers and the wild nights of Mazeppa, Delacroix turned to mythology. Its heroes and demi-gods, with their attendant courts, began to flow from his brush in 1838 in the great state-commissioned frescoes which made him France's greatest decorator. Some people however, saw the hand of Thiers, prime minister in 1836 and 1840, in the work given to Delacroix. The *Journal des Artistes,* writing about the Palais Bourbon frescoes, said: "We accuse those in the government and the legislative assembly of intriguing in favour of persons who owe their reputations not to talent but to the work of cliques and pressure groups." Delacroix ignored the whisperings and proceeded to create his great antithesis of war and peace for the parliament building. One of the episodes shows the world of ancient Greece and the birth of civilization under the title of "Orpheus teaching the People the Arts and Peace". To present this vista of a golden age of Arcadian splendour, Delacroix drew much on Raphael, Titian and Poussin. It contrasted starkly with the spectre of war as represented by Attila, the bringer of destruction and barbarism: an image which Delacroix made into "a terrible hymn to suffering and irremediable death". His picture of the "Scourge of God" stands alongside other scenes of death and desolation: the slaying of Archimedes, Pliny the Elder asphyxiated by the sulphurous fumes of Vesuvius in eruption and the wickedness of the Jews in Babylon. In 1840–6, he painted the frescoes in the Palais Luxembourg which he dedicated to Dante and the great men of the ancient world who appear in the fourth Canto of the Inferno. In 1850 he was commissioned to decorate the ceiling of the Apollo Gallery in the Louvre. Like Le Brun two centuries before, Delacroix chose to portray the triumph of Apollo. His painting showing the victory of Apollo's team of four horses over the python marked a great success for Delacroix, the "Robespierre of painting", as he was known, over his malevolent, short-sighted critics. A remark about the "Apollo" is revealing: "The corpses in the python painting were entirely my own work; I would not have succeeded so well if I had used models, and this freedom that you see here is due to their absence."

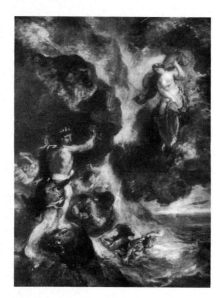

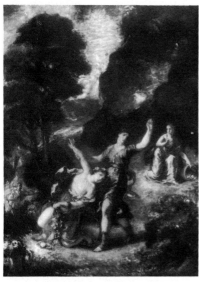

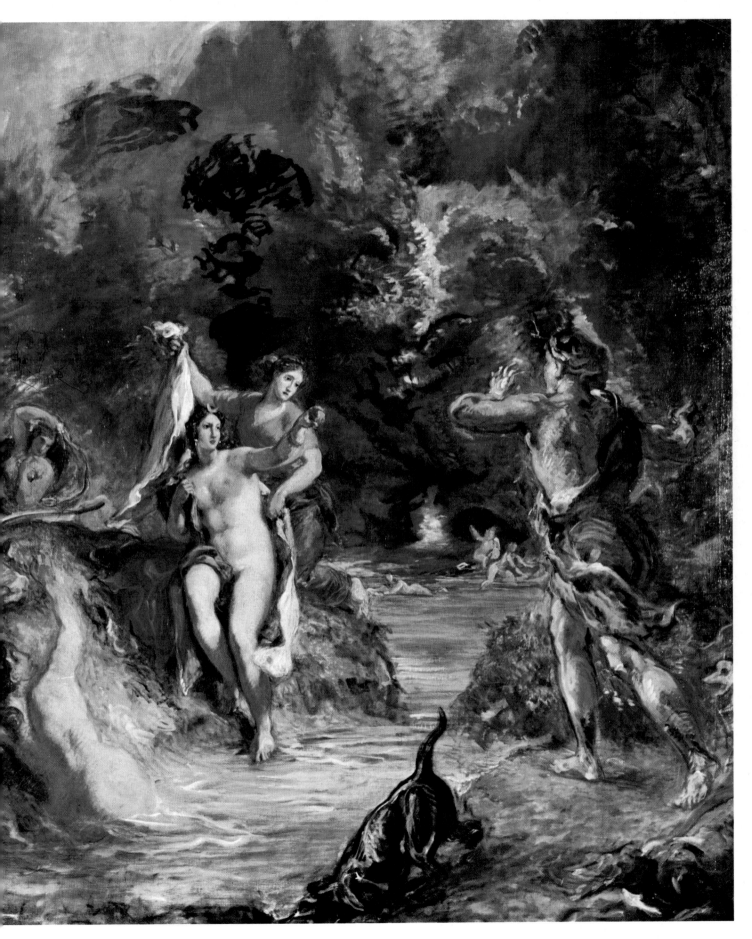

AN ANGEL APPEARS: AND THE LAST FIGHT BEGINS

An angel appears before Jacob as he travels on his way. The angel will not identify himself and Jacob and the stranger wrestle until dawn. After the struggle, the angel still does not give his name but he blesses Jacob. "It is a trial that God sends to his chosen ones." was Delacroix's comment on this story from Genesis, and he painted "Jacob wrestling with the Angel" (St. Sulpice, 1860). For Delacroix, the struggle symbolised the long-awaited battle, the struggle with a mystery which leads a man to leave the road that has been marked out for him. Throughout his life, the painter fought against meanness of spirit, against lack of understanding, against himself even, and won glory. At the end of his life perhaps the thought came to him that his whole existence was to culminate in the same struggle as Jacob's. The greatness of the struggle with the angel is its futility which still does not quell the will to win, a motive that justifies the effort of living. The challenge has been laid down and must be accepted, the great temptor is not to be disregarded. Perhaps Delacroix was trying to say in this painting that his attitude to God was now much different to what it had been in his earlier days. This will never be known. The painter had heard in the cathedrals the mighty organs singing out their great cantatas which suggested a Presence and man's search for it. Delacroix too struck out for this inexpressible Being and in doing so found peace of mind.

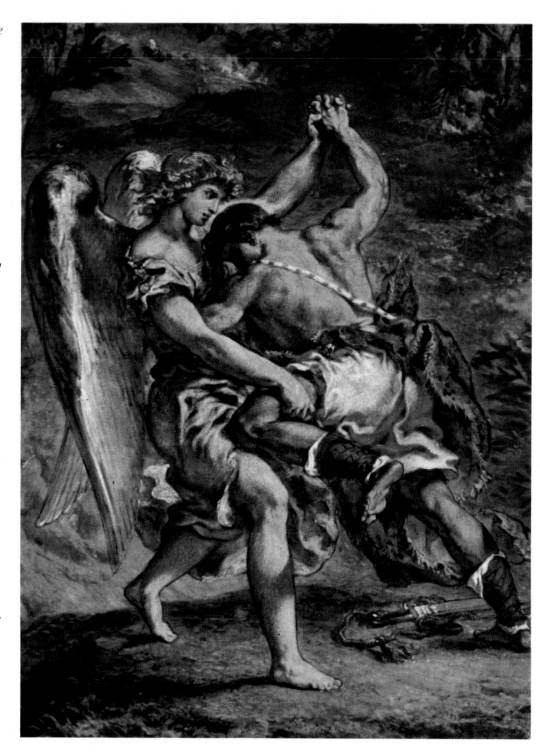

74

"How I would like to return in 300 years' time to hear what is being said about me." Delacroix was a sound judge of his art. During his life, he had been the cause of scandal in a Paris newly emerged from the age of the guillotine and the imperial myth. After his death he and his work were gradually set aside and forgotten. This was to a great extent due to the art dealers wishing to clear the way for the Impressionists who themselves looked on Delacroix as an important link with the past. A few years ago, on the centenary of his death, exhibitions and wise critics restored him to the world of art as a disturbing and deeply committed painter. His art, born of a combination of feverishness, solitude, memory and imagination, could well be the art of our own troubled times. Taine said of him: "The glory of Delacroix's art is its striking sense of the present." The question arises whether a figurative painter can be regarded as a modern. Baudelaire already saw in him the surrealist while he met with the approval of the Impressionists and Van Gogh. This solitary genius certainly showed the way for modern art. The greatest tribute that can be paid to him is not that he was one of the leading Romantic painters, but that his whole life and art were constantly pledged to excelling at everything he did.

1789 – April 26: Ferdinand Victor Eugène Delacroix is born at Charenton-Saint-Maurice to Charles Delacroix and Victoria Oeben. His resemblance to Talleyrand later aroused suspicions that the great French minister, a close friend of the Delacroix family, was the artist's real father.

1806 – enters the Lycée Louis-le-Grand and takes up classical studies.

1815 – becomes the pupil of Guérin but later rebels against academic teaching, preferring to study the works of Rubens and Veronese in the Louvre. Becomes the friend of Bonington, one of the greatest of the English landscape painters of the early 1800's who played an important role in French Romantic painting.

1821 – Charles Baudelaire born in Paris. He was to become a close friend of Delacroix and devote some of his finest critical works to his painting.

1822 – Delacroix makes his debut at the Salon de Paris with "Dante and Virgil in Hell", and meets with a stormy reception.

1824 – Delacroix exhibits the "Massacre at Chios" provoking further violent criticism. Géricault the painter dies in Paris. Like Delacroix, he is a former pupil of Guérin who rebelled against his teacher. Géricault greatly influenced Delacroix, and his painting "The Raft of the Medusa" (1819) inspired Delacroix's "Dante and Virgil in Hell" (1822).

1825 – Delacroix visits England from May to August. The visit proves important in his artistic and cultural formation.

1827 – Confrontation between Ingres and Delacroix at the Salon. Ingres, the Classicist, exhibits "The Apotheosis of Homer" while Delacroix the Romantic shows "The Death of Sardanapalus".

1831 – exhibits "Liberty leading the People", inspired by the July revolution of 1830 that led to the Bourbons being driven from the French throne. The new government awards Delacroix the Legion of Honour.

1832 – visits Morocco and Algeria, bringing back many vivid impressions and a wealth of materials for subsequent paintings. Exhibits his portrait of Paganini.

1833 – Delacroix is commissioned to paint the King's chamber in the parliament building (Palais Bourbon) in Paris.

1834 – paints the "Algerian Women".

1835 – The painter Gros drowns himself in the Seine. He marked the transition from neo-classicism to Romanticism.

1836 – Delacroix begins his series of lithographs for Goethe's *Gotz von Berlichingen*".

1837 – begins working on "Medea".

1839 – visits Amsterdam with Elisa Boulanger to see the paintings of Rubens and the Flemish school. Exhibits "Cleopatra" and "Hamlet in the Graveyard" at the Salon.

1840 – paints "The Taking of Constantinople" and "The Justice of Trajan".

1841 – Exhibits his "Constantinople", "The Shipwreck of Don Juan" and the "Jewish Wedding" at the Salon.

1845 – completes his series of paintings on mythological heroes and celebrated poets and philosophers of the ancient world for the library in the Palais Luxembourg. Also exhibits at the Salon, his works provoking lively criticism. Paints "Orpheus teaching Men the Arts and Peace" and "Attila bringing back Barbarism to a ravaged Italy".

1849–51 – paints the ceiling of the Apollo Gallery in the Louvre.

1849 – is present at the death of Chopin.

1850 – visits Holland for a second time, this time alone.

1851–4 – paints the ceiling of the Peace room in Paris's Hôtel de Ville to depict "Peace consoling Humanity". Paints eight coffers with representations of Venus. Bacchus, Minerva, Ceres, Mars, Mercury, the Muses, Neptune and the Labours of Hercules.

1855 – exhibits "The Lion Hunt" and "The Two Foscari" at the Universal Exhibition.

1856 – is admitted into the *Institut* to take over the place of the painter Delaroche.

1859 – exhibits at his last Salon with "Ovid with the Scythians", "St. Sebastian" and "Christ laid in the Sepulchre".

1861 – despite frequent attacks of ill-health, completes his paintings for the Chapel of the Holy Angels in St. Sulpice: "Heliodorus expelled from the Temple", "Jacob Wrestling with The Angel", "St. Michael casting down the Demon".

1863 – paints "Tobias and the Angel". Dies in Paris on August 13.